A Child from Everywhere

Photographs and interviews of children from 185 countries living in the UK

To Judith

Hope you enjoy the children.

Caroline Irby

Caroline Irby

black dog
publishing

Contents

Foreword
Aminatta Forna

On the wall above the desk where I sit hangs a picture of a young girl in Sierra Leone. She stands wearing a torn dress, which is not really a dress but a top made for an adult woman, doubling as a child's garment. In her hands she holds a Barbie and she fixes the camera with a candid gaze and a slight, secretive smile. On closer inspection the viewer sees that the Barbie is in two parts, the child holds the doll's head in her right hand and the body in her left. She seems to think this is funny. I think it's funny, too. I know this little girl. She's a cousin on my step-mother's side of the family.

Downstairs in our kitchen is a picture of a boy walking along the shore of the Niger River. He is in partial silhouette, wearing a fancy red leather coat and a conical straw hat, a hound slinks behind him. I met the boy in Mali. We talked about his dog, which followed him everywhere, and his dream of being a tailor. The fancy coat, acquired from a second hand stall in the market, I could imagine starting life in the Portobello Road. I liked the boy. I took his picture and when I reached home I hung it on the wall. Fifteen years on he is there still, forever ten years old. I look at him over breakfast in the mornings, I wonder what has become of him.

Looking at the images contained in this book I have been thinking these past few days of what one finds so moving about images of childhood. And I think it is this: that those children whom I met, and the many in this book I have never met, confront us with an idea that confounds us. It is that happiness exists, thrives even, where our adult values deem it has no right to. How can a child born into the poorest country in the world feel such joy? How can a child with nothing to play with but a broken doll tell us that what we think matters does not matter? How can children uprooted, displaced, sometimes away from their parents, who have become outsiders in a new land, sound so cheerful? They are happy despite everything. And they are hopeful. Our hearts are uplifted at the same time as we ask ourselves—how long can such happiness last, how fleeting is such hope?

These children from everywhere have arrived in this country as the sons and daughters of anthropologists and asylum seekers, florists, sportsmen, nurses and chefs. They have come in search of something better, or simply to escape something worse, because of their parents' dreams, or at the expense of those dreams. They have struggled with the challenges of language and of looking different, with cold and with Scots accents. They come with and without their parents, arrive among strangers and inevitably leave behind people they love. For some Britain is a place of safety, for others Britain is a place where danger lies on the streets, where nobody knows your name. They feel fear, awe, excitement, sorrow and shock. Emmanuel is amazed by the changing of the seasons. Lisa sat through her classes without understanding a word that was said. Oumou was stunned by the quantity of white folk. Moeko removed her shoes before stepping through the door of her new home.

To the children Britain is shops. Britain is parks. Britain is a place without lizards. Britain is taps delivering hot and cold water. Britain is a place where people are always late. Britain is the internet. Britain is humour. Britain is more shops. Britain is skinny jeans. Britain is small

teeth. Britain is people who don't dance well. Britain is stones through the window. Britain is no friends. Britain is new friends. Britain is freedom.

Memories of the place from which they have come are memories of an earlier childhood or of holidays back home. Iceland is dried fish, wool sweaters and sunless winters. Liechtenstein is cake. Congo is fu fu. Argentina is poor people. Oman is black dresses. Benin is black people. The Seychelles is waterfalls and sunsets. Finland has ten million sweetie shops. In China nobody is ever late. In Cuba they rumba. In Cyprus people are friendly and try to look the same. In Guyana there is always something happening and boredom is unknown. In East Timor the people know their neighbours, just as they do in Lebanon. In Guinea Bissau the people are poor, but nobody eats out of bins. Nobody in Senegal ever does anything bad. And people in Britain have no idea that Angolans have food.

Caroline Irby's images capture children in a place in their life where they seem to be balanced upon an axis between past and future. They are perhaps more acutely aware of the past than their British peers, for the past is—quite literally—another country. Consequently the future is all the more deeply imagined. Theirs is a future in which we would see an Uzbek born JK Rowling, a Mexican born professional Irish dancer, a fashion designer who started life in Cape Verde, and a great many former child migrants return as adults to help the countries they left.

What one is left with after viewing these startling images is a sense of how complex, subtle and multi-layered are their definitions of selfhood. The children from everywhere have a perspective which goes beyond what is obvious: their horizons are boundless, their perspective alternative, their vision already global. Simply put, they think differently. They never use the word 'home' for already and without knowing it, they have begun to redefine ideas of home as fixed and solid, locked in place by geographic boundaries, a place which offers sanctuary on condition of conformity and excludes difference.

These are children born at the crossroads of culture, of nationality, of politics and history. Theirs is the road without a map, the road less travelled; in order to understand themselves they have to and have already begun to understand so much more. The crossroads is a place of danger, but also of opportunity. It is the place where all the greatest journeys begin.

Introduction
Caroline Irby

Wherever I am working in the world, I often find myself telling the story through the children I meet. I have listened to and photographed children in Sierra Leone and Haiti, Darfur and Kashmir. I enjoy their company but also feel they give the most sensitive and perhaps most accurate expression of what is happening in any given situation.

In my own country, the United Kingdom, there is an extraordinary story—an unprecedented demographic event—unfolding. The United Kingdom has long been a focus of immigration, but whereas in the past there have been concentrated influxes from isolated areas, we now have almost all the world converging on one place. And of the estimated 565,000 migrants who arrive here each year, 26,000 of them are children.

I spent just over a year looking for one child from every country in the world now living in the United Kingdom, then photographed and interviewed each one. The criteria were that the children were aged nought to 16 and born in their native country to both parents of the same nationality.[1] There are 192 countries in the world (as recognised by the United Nations as sovereign states). Eventually I found children from 185 countries living here, all of whom feature in *A Child from Everywhere*.[2] I was fascinated by each child's story, and by the collective insight they gave into the effects of globalisation.

One defining characteristic of the recent wave of immigration to the United Kingdom is its reach, and the places I travelled to in search of these children broadly reflects their diaspora. Whilst immigrants have settled predominantly around the capital and in major cities across the country, it is also possible to find a family from Chile living in a Scottish archipelego, or a boy from Sao Tome in a Midlands market town. And so I travelled from the Orkney Isles to the Isle of Wight and from Belfast to Cornwall, experienced the hospitality (the meatballs, the couscous, the chocolate in unfamiliar wrapping) of families from every continent, and was given both a glimpse into the countries from which the children came, and a 185-layered image of my own country.

The search was easy at first: almost any school in an inner city area of our largest cities will have an ethnic mix of pupils reflecting the world's wars, natural disasters and despotic regimes. But as the months went by, the task became harder and behind many of the interviews and photographs in this book lies an intricate web of phone calls, emails and train journeys. The search for a child from one particularly evasive country might, and did, take me from a remittance centre to a butcher's shop to a doctor's surgery to a record store to a church, and finally to a block of flats a few hundred metres from where I live. The year was a giant treasure trail, with each set of clues leading to a child who offered something different and surprising.

I called on schools, city councils, refugee groups, religious institutions, universities, embassies, family, friends and a myriad of cultural organisations for help. I attempted to conscript almost anyone I met who sounded like they came from overseas: I was given leads by the postman, a lady in the swimming pool changing room, the driver of a freight truck parked outside my home... And finally, when I reached 160 children, I was given another burst of energy and ideas

by researcher Emily Butselaar. Without the willingness and suggestions of all these people I would still be staring at a wish list of 192 countries.

The scale of contemporary immigration offers up plenty of statistics, often cited and analysed in the media. But behind each number lies a story, and these stories often remain untold.

I stumbled across Khulan's story at a secondary school in Leicester. I had been given a list in advance of the nationalities represented at the school, but when I arrived the secretary remembered one more. Khulan looked the archetypal British teenager; three years earlier she had been living a nomadic life on the Mongolian steppe, sleeping in a yurt and herding sheep and camels. I asked only a few questions: her story poured out almost unprompted. I sat back and listened and was captivated. An hour later, as I was about to turn off my microphone and begin photographing, Khulan added:

"I've never talked about this since I'm here. I got a little brother who was born here, he's two and a half. I really enjoy taking about all these things again—I just can't wait for my brother to grow up and tell him everything about Mongolia. I just can't wait."

In the meantime, I hope you will enjoy hearing her story and the stories of these children from everywhere who have come to live in the United Kingdom. My encounters with them were rich; I hope yours will be too.

1 Where it was not possible to find children fitting these criteria, I included children who came as close as possible: twenty of the children in this book were born outside of the country of their nationality (for example the Kiribati child was born in Fiji); seven of the children have parents from two different countries.

2 I believe there are no children living in the United Kingdom who have come from Marshall Islands, Federated States of Micronesia, Nauru, Palau and San Marino. I could not find children from Central African Republic or North Korea who were willing to take part.

A Child from Everywhere
Leaving and Arriving

Guatemala
Armenia
Chile
Philippines
Rwanda
Estonia
Nicaragua
Somalia
Tonga
Venezuela
Netherlands
Thailand
Liberia
Suriname
Portugal
Belize
Algeria
Congo (DRC)
Haiti
Colombia
Tajikistan
Barbados
Georgia
Japan
Italy
Sao Tome
Zambia
Jamaica
Laos
Trinidad and Tobago
Solomon Islands
Mali
Yemen
Slovakia

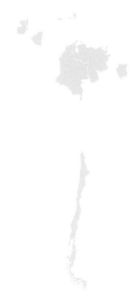

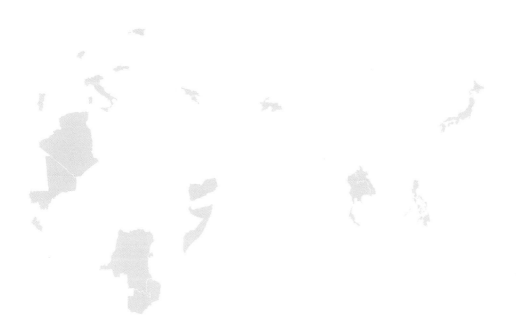

Looking Back The Future

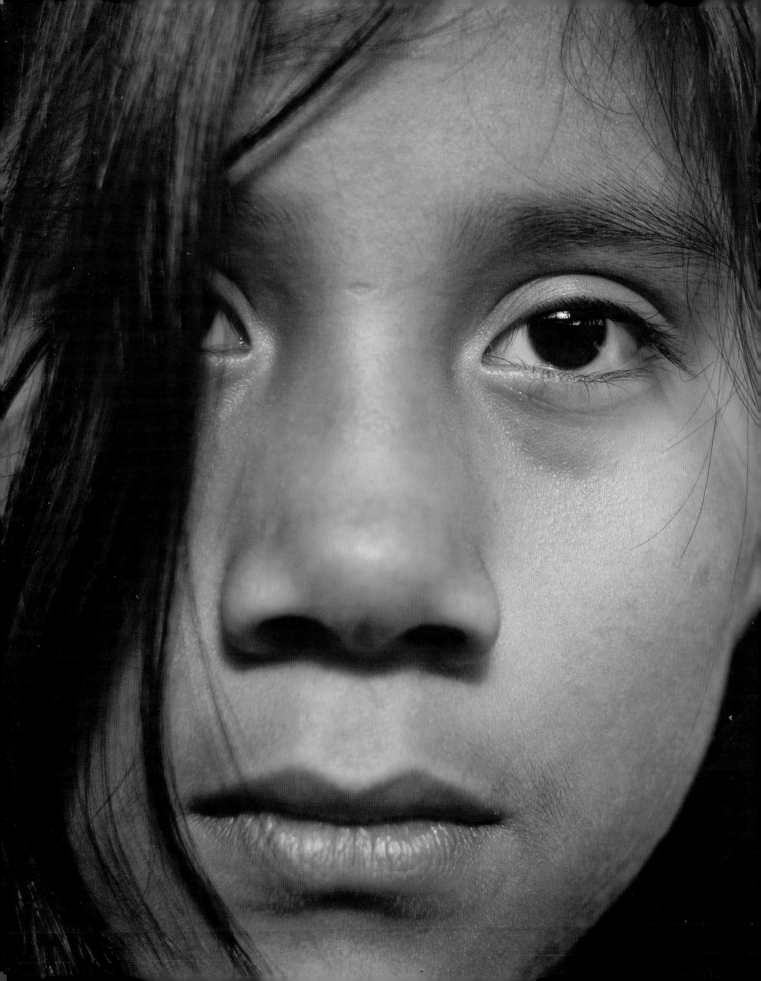

Aura, 8

I only remember that I was born in the mountains. My actual parents couldn't look after me because I was their seventh child, then I went to an orphanage. My parents now were looking for another child to adopt and they saw a picture of me and they came to visit and took me home.

I was about two or three months old when I came from Guatemala. I have a life book [my adoptive parents made] about when I was little. It has my birth certificate, a picture of me when I was really little in the orphanage, a picture of my mum when she collected me, and my ticket for when I went back to England. And they just welcomed me home.

There is a poem my mum wrote there:

Not flesh of my flesh
Nor bone of my bone,
But still miraculously my own.
Never forget for a single minute,
You didn't grow under my heart,
But in it.

I am Guatemalish and I do think about it: like if I did stay there, what I would be doing? Probably making those bracelets or working in fields.

Guatemala > Oxford 8,370 km

Yeranuhi, 15
There's loads of immigration and people don't just come here for no reason. There is a reason for them to come.

Juan, 3
Juan's mother, Perla: We came to Orkney because my husband was transferred here to be head of production for a salmon farm. I never imagined I'd have the experience of living in Europe and so far away.

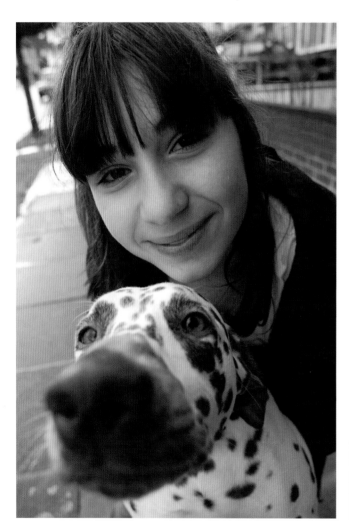

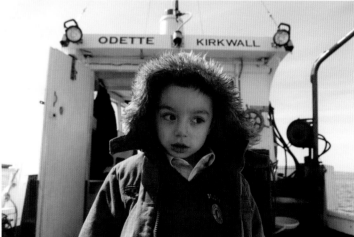

Armenia > Northolt 3,930 km

Chile > Orkney Isles 11,318 km

Kenneth, 11

My mum is a nurse and my dad is an assistant. They're supporting my grandmothers, my aunts and uncles. Sometimes I like to live here because we can help my family—we can earn much more money.

Mansury, 15

I remember me and my family walking across the road, and I can remember a guy on the side. Half his leg was blown off. That's all I can remember of the war. I came here looking for a better life.

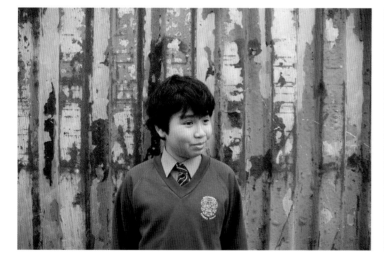

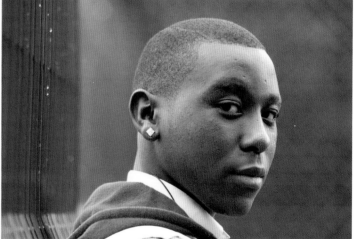

Philippines > Portadown 10,989 km

Rwanda > Manchester 6,966 km

Johannes, 10
I came here because my dad is working as an anthropologist
studying nomadic reindeer herders.

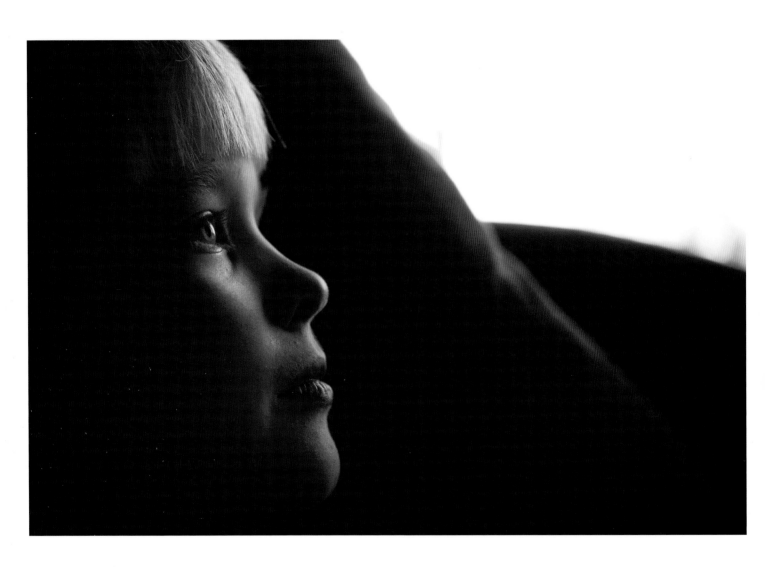

Estonia > Cambridge 1,903 km

Adriana, 8 months

Adriana's father, Ramon: My country is poor and no have job
I need a better future for my kids.

Gulaid, 15

My father told us we got problem, we cannot stay there: some
warlord beat my mother. We just went quickly, without knowing,
on the road two nights and two days. We had to move.

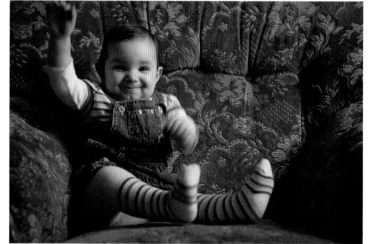

Nicaragua > London 8,249 km

Somalia > Cardiff 7,068 km

Ungatea, 2
Ungatea's father, Chris: I play rugby over here with the Harlequins so we just came over. There are many Tongans living round here. Most of them play rugby.

Santiago, 7 months
Santiago's father, Roberto: I'm doing a PhD and as we're here for four years, he can learn English better than me. Probably with only this he's going to improve his opportunities in Venezuela.

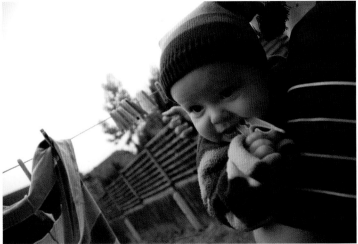

Tonga > Sunbury-on-Thames 16,146 km

Venezuela > Nottingham 7,478 km

Peter, 16
My parents started out a florist here in Totnes and they're
spreading out their business all over the UK.

Iyara, 15
My mum and my dad work in Edinburgh so I have to follow them.
They are chefs. My friends in my school were crying: they don't
want me to leave Thailand.

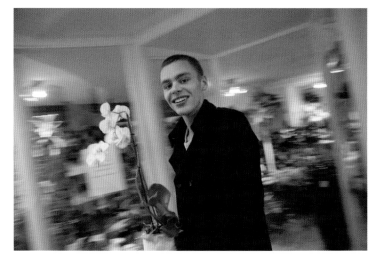

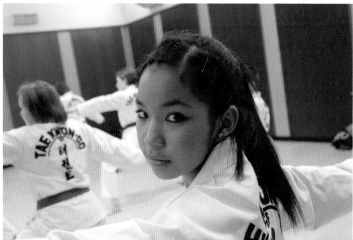

Netherlands › Totnes 669 km

Thailand › Edinburgh 9,541 km

Johnette, 16

It all started with the war. I was coming home from school one day and I saw people running about, going crazy. I went down to the bus stop but there were no spaces on the bus; people started fighting so I decided to walk—to my house was about two hours. I was crying and scared because people were shoving each other, trying to get to safety, so I decided to run. Luckily my mum was coming up the road and she saw me and we went home.

A day passed and there was no shooting so everyone calmed down again and started living normally. Then it all started again—it got worse. My mum, she was scared but she started acting brave because she didn't want us to be scared. Luckily her boyfriend came and got us and took us to this place in town. On our way we had things on our head, bundles, and this bullet just missed me—my mum screamed.

We finally got there and there were so many people in one building—it was well dirty. There was one bathroom for everyone so it was filthy: disgusting sewage and flies everywhere. Everyone was crowded up in this tiny room, crouching up and praying in the night. Some people would be crying and you'd hear babies screaming. During the daytime, there was a little market outside. My mum would go and get some stuff—sometimes she don't find anything much but she don't eat and gave us the food instead.

We were there for a long time. There was a loud gun sound everywhere—lots of rockets keep dropping and the sound got louder and louder and it went on forever. It was horrible.

After the war my dad sent for me. I refused to come cos I said I don't want to leave my mum—I didn't even know my dad actually. He said, "Any children would kill to get this opportunity you've got and you're refusing it. You're going whether you like it or not."

So here I am: I'm in England!

Liberia > Northampton 5,301 km

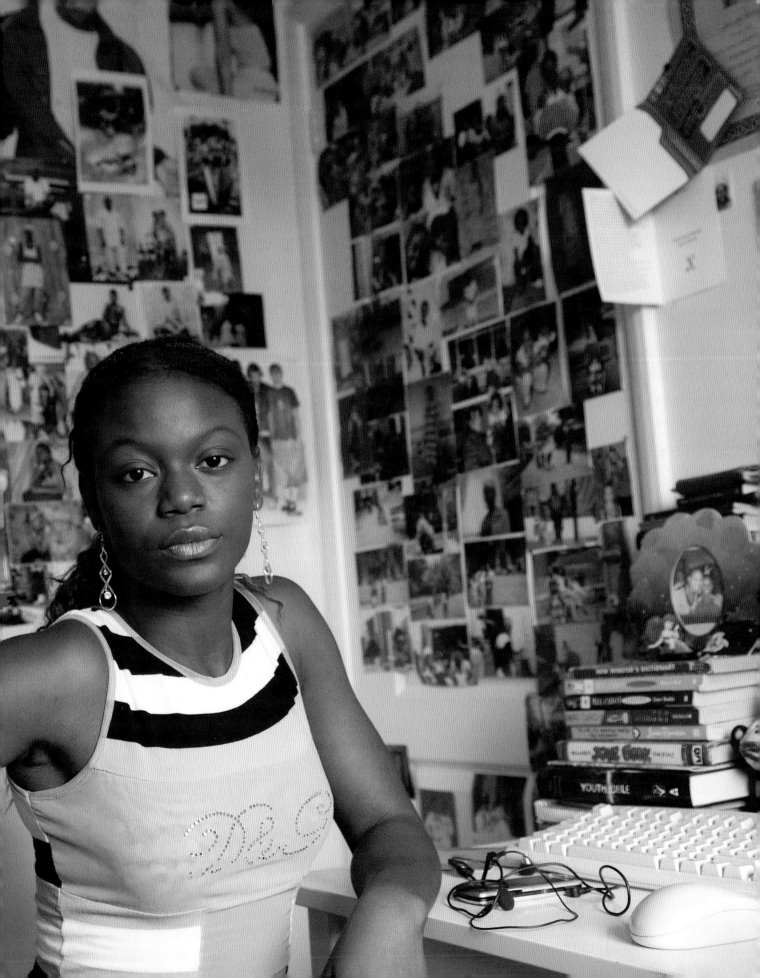

Lloyd, 15

I came to live here because my mum got married. I knew I would enjoy it, I knew I would have a better chance of doing what I could do. I expected most things that I saw on TV, like when it's cold, smoke coming out of people's mouths.

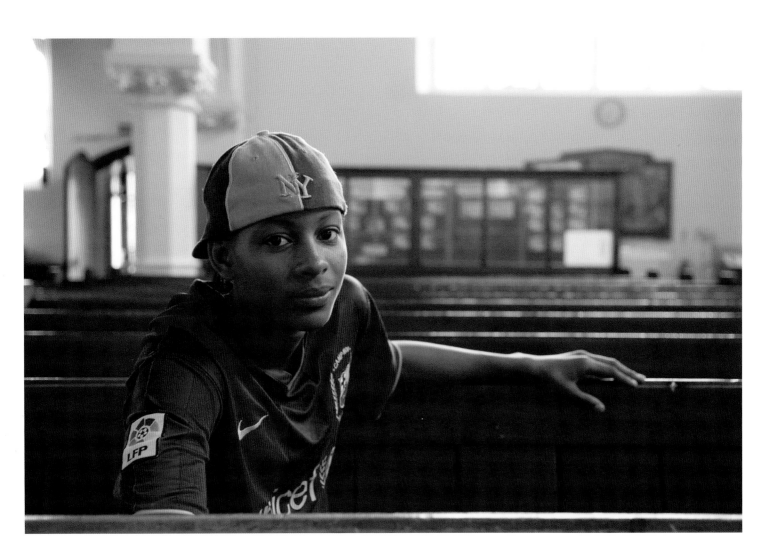

Suriname > London 7,259 km

Carolina, 15
My mum and father split. My mum decided: she has family here
so she wants to be more close with her family.

Jacqueline, 16
I was eight years old when I first moved here. I didn't have
a choice. I had to move with my parents.

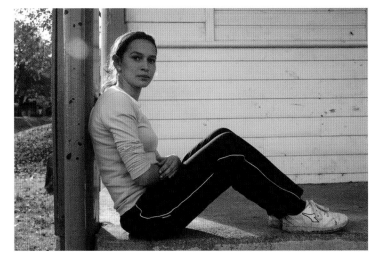

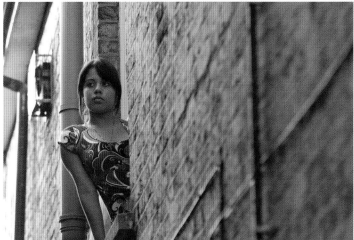

Portugal › Edinburgh 1,639 km

Belize › Croydon 8,118 km

Ashraf, 13

There was terrorists in Algeria so I came here. I wanted to come because some of my family live here and there's no terrorists.

Israel, 10

I used to play with my granny, and my granny would teach me lessons about life: how to be careful because there was a war in my country. I was crying on my way into the airport: every time I turn my back, I feel like seeing my grandma.

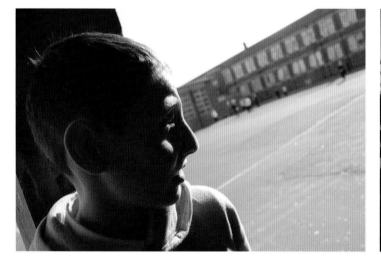

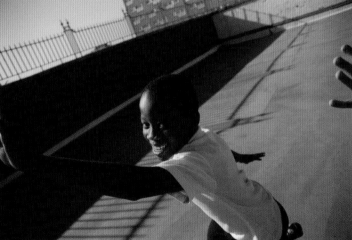

Algeria › Glasgow 2,945 km

Congo (DRC) › Southampton 5,558 km

Cindy, 9

When I left Haiti I felt free. Many things happen in Haiti that are not good. One time I got attacked with two robbers and they wanted to kill my driver. Kidnappings happen all the time: my uncle was kidnapped. Sometimes I wake up and I'm scared because I do bad dreams about Haiti.

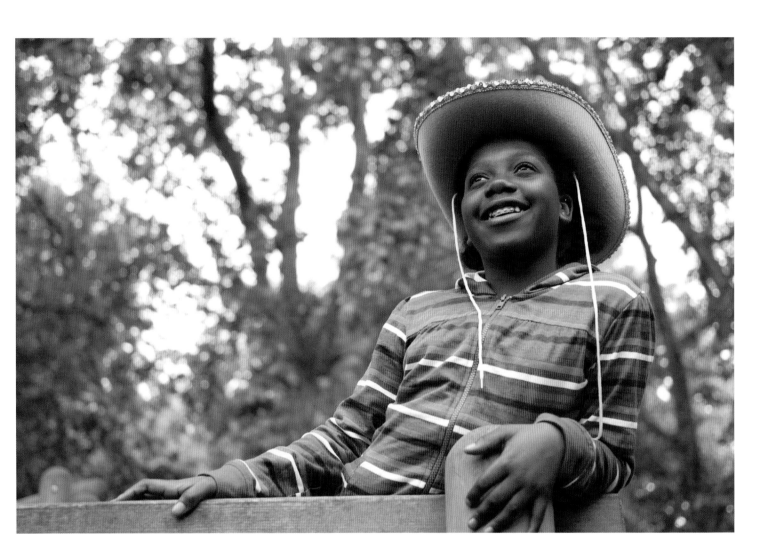

Haiti › London 6900 km

Marcella, 13

It was really hard for them to leave because my mum, she got the opportunity to become a doctor and that was her dream, she wanted to do that so badly. Unfortunately, because there was a war in Colombia, we had to come here. Over here my mum cleans houses and my dad's a manager. He tells people where to clean.

Gazanfar, 12

I'd never been in an aeroplane. There was a button there: I pressed the button and then the man came and talked in English. I didn't know what he was saying. I thought, 'Why is he here?' After, I pressed it again and he came and then I realised the button was if you need some help.

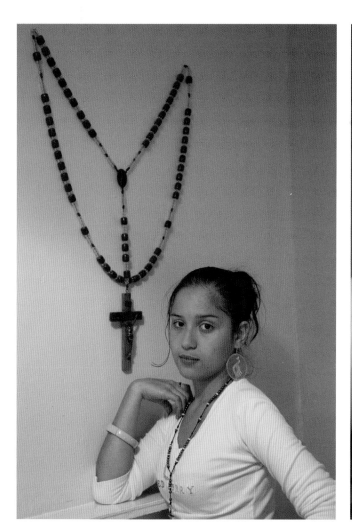

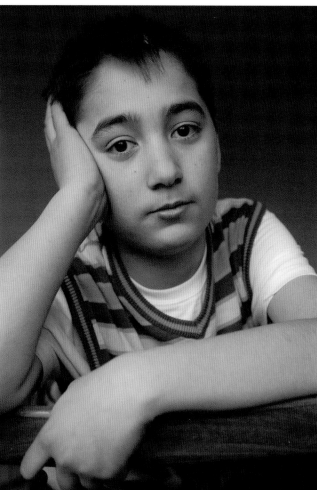

Colombia > London 8,220 km

Tajikistan > London 5,683 km

Amanda, 14

During the plane ride I wasn't too scared or anything but we finally got here and it was all freezing and cold. Then it hit me that I was in England to live.

Irakli, 11

I hadn't seen my mother or father for six years. They came here to get more money. When I saw them again, my dad came to my country to pick me up and brought me to my mum at the airport. I didn't know who they were. I didn't remember their faces.

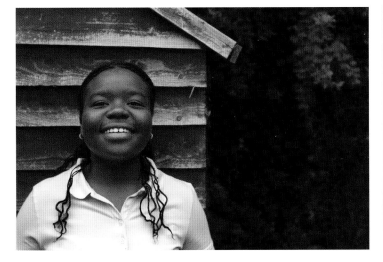

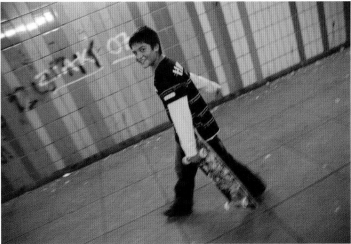

Barbados > Watford 6,607 km

Georgia > Southampton 3,693 km

Moeko, 5
We arrived in the night. The door looked like my front door in Japan so I thought all the block was my flat and I took my shoes off outside.

Japan > Cambridge 9,357 km

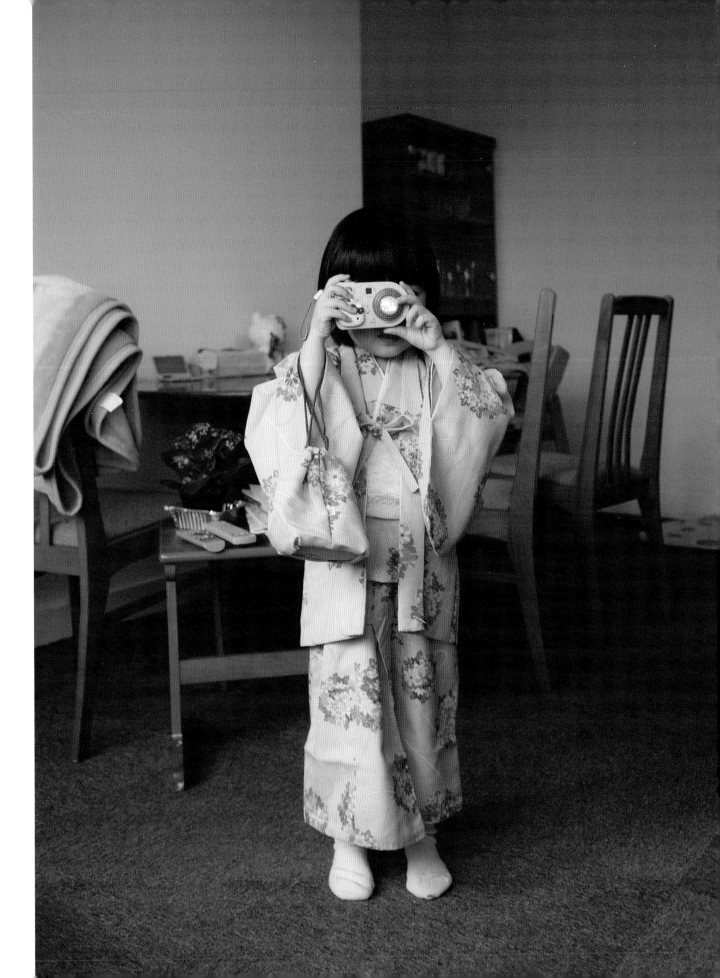

Luca, 16
I suppose it was kind of like stepping onto an alien planet....

Jaime, 9
It was busy and dark and cold. I was lonely and I had no one to play with.

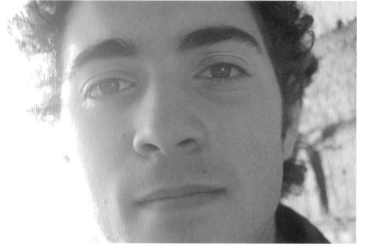

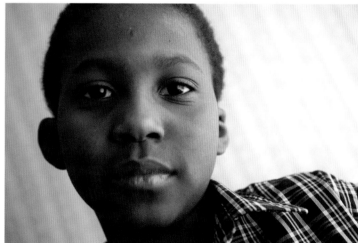

Italy › Cambridge 1,747 km

Sao Tome › Rochdale 5,975 km

Fernanda, 14

My mum is my hero. It was seven and a half years since I'd seen her and when we saw each other again, I just felt something I've never felt before—unexplainable.

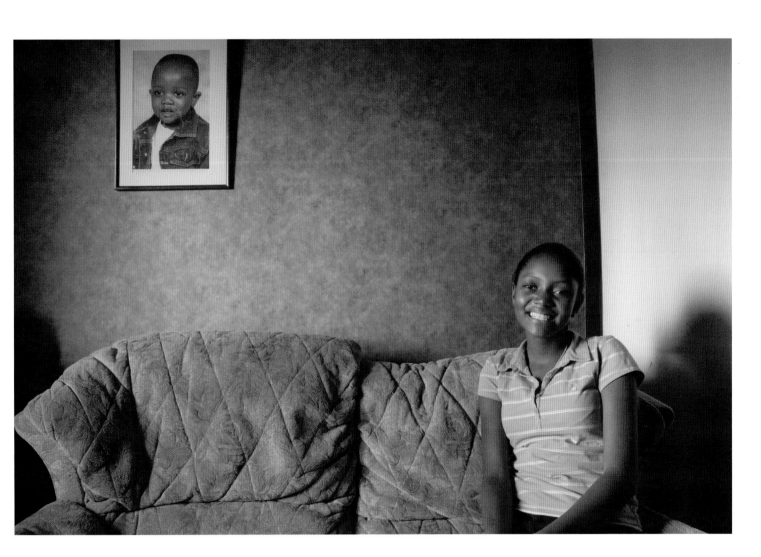

Zambia › Glasgow 8,317 km

Shamar, 8
When I arrived in England I was scared. In school I was scared
as well. I didn't know what to do.

Vasanar, 2
Hello.

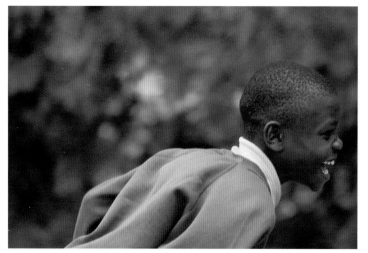

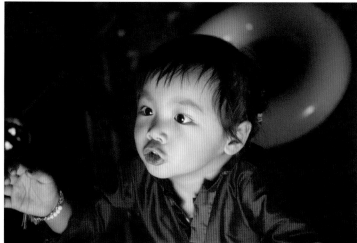

Jamaica > Tidworth 7,298 km

Laos > London 4,311 km

Aliyah, 6
I felt really, really sad.

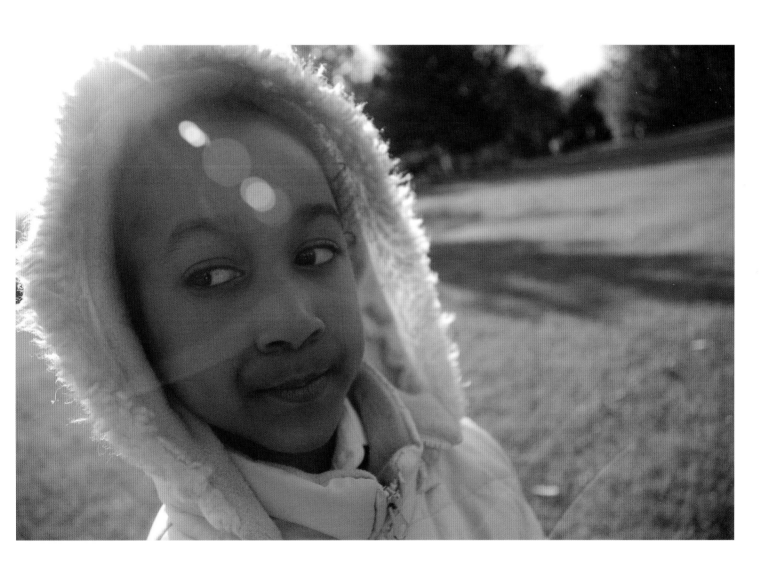

Trinidad and Tobago › Southampton 6,895 km

Vanessa, 10

I was very excited. I came out and there was some snow on the stairs and what I done was I said I was the first one to touch the snow.

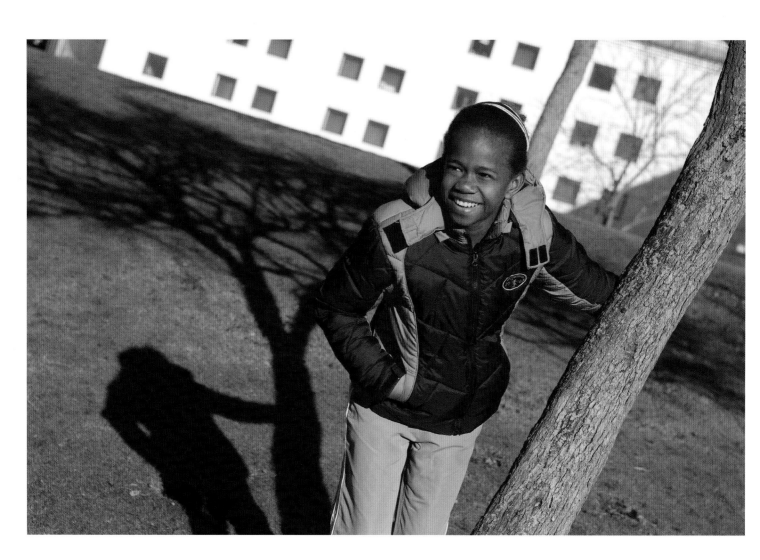

Solomon Islands › Norwich 14,668 km

Oumou, 16

I had only seen a white person once: a cousin got married to a white woman. When I arrived here I was shocked: I saw so many white people. I didn't think there was so many of them!

Aiman, 14

I still remember the moment I stepped out of the van in Cardiff for the first time. My grandfather was driving and the luggage was still in the back. I looked around and I said, "What a beautiful place."

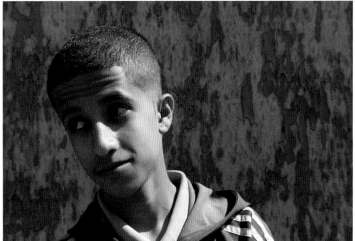

Mali > London 4,111 km

Yemen > Cardiff 6,148 km

Maxi, 10

I said, " Wow, that be so fantastic here." You can do everything here, not like in Slovakia. You can learn English, which is everywhere on the whole planet. You can have a good job.

Slovakia > Manchester 1726 miles

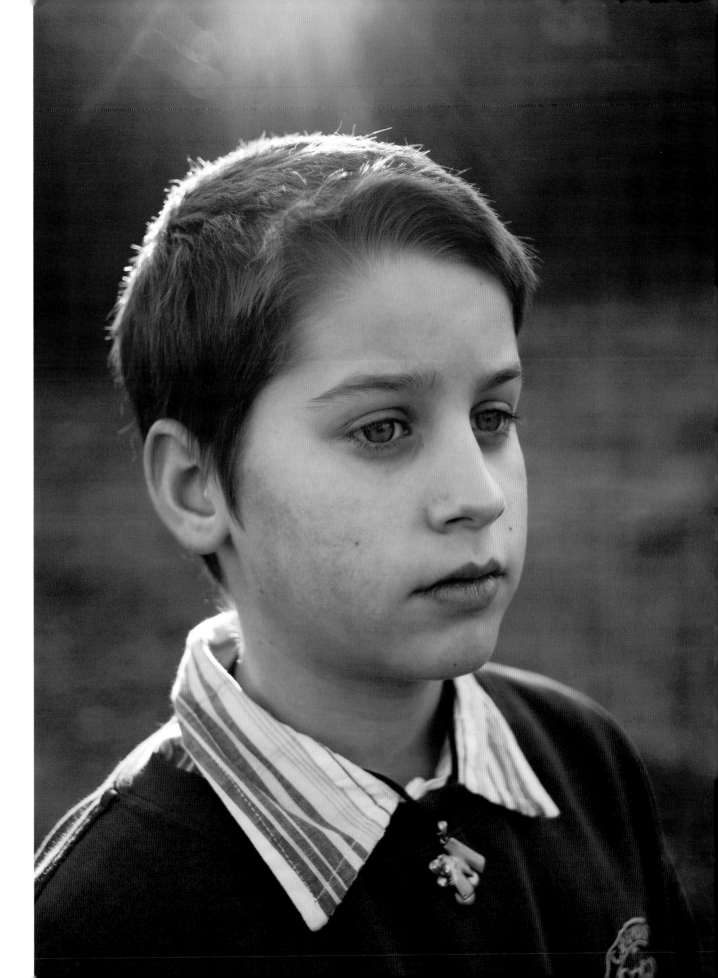

A Child from Everywhere
Settling In

Poland
Ecuador
Zimbabwe
Mauritius
Latvia
Samoa
Indonesia
Nigeria
Jordan
Iran
South Korea
Iraq
Nepal
Hungary
Denmark
St Lucia
Sudan
Uganda
Chad
Guinea Conakry
Bangladesh
Fiji
Andorra
Singapore
Bulgaria
Djibouti
Ethiopia
Kuwait
Bahamas
Kenya
Turkey
El Salvador
United States of America
Bosnia and Herzegovina

Looking Back

The Future

Izabel, 7

I though it wouldn't be so fun, but it is. I thought that I won't make friends and I won't have nobody to do anything with.

Lisa, 15

It was hard: I used to sit in class and not understand anything.

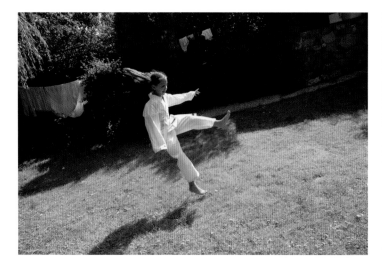

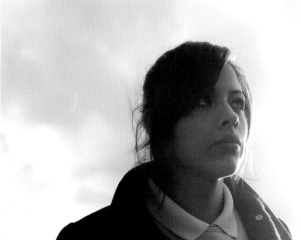

Poland > Windsor 1,612 km

Ecuador > Cambridge 9,115 km

Tufadzwa, 8
I didn't know what language they were speaking—I couldn't understand them. They were all in the internet plus going to the cinema—I didn't know what the cinema is—plus having different sort of food that I never knew plus I hated. I did not like the look.

Neaty, 15
When I first came here, people weren't sure what I was like and there was bullying that went on. I think that's a big thing, probably, for a lot of people that come here.

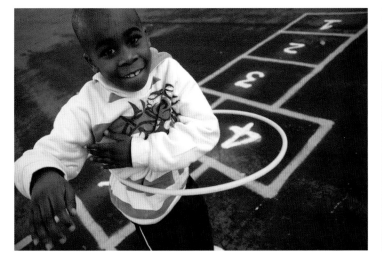

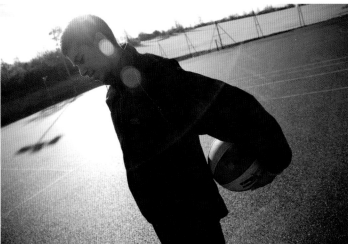

Zimbabwe > Oxford 8,700 km

Mauritius > Cambridge 10,117 km

Dajane, 9
They're not so friendly like in Latvia but I think they are going
to be friendly after.

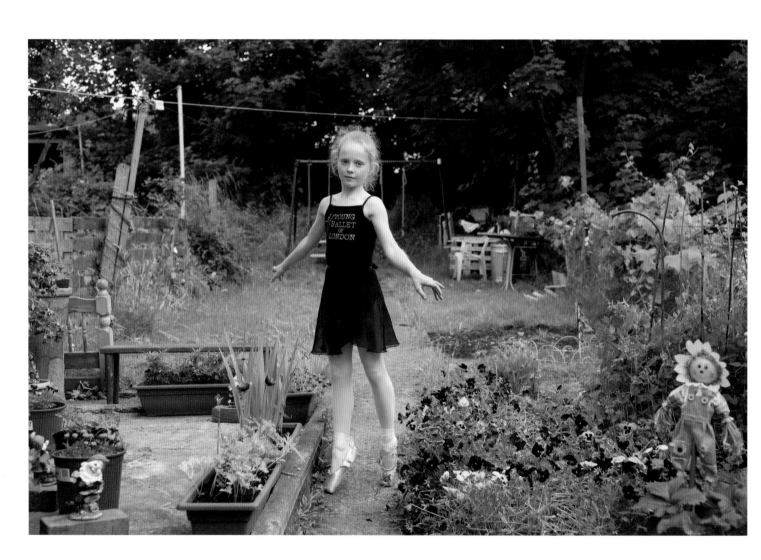

Latvia > London 1,841 km

Daniella, 10

I'm a bit different to all my friends at my school: I'm darker and taller than them. I'd love to go [to Samoa] and just know that I have family there and that I'm not so very different to everyone as well.

Galindra, 2

Galindra's father, Franz: She's just realised that her good friends are no longer here. She mentions them and asks to call them so maybe she's realised that she's now in different country.

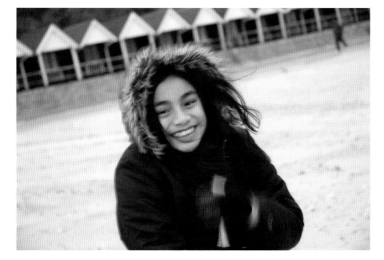

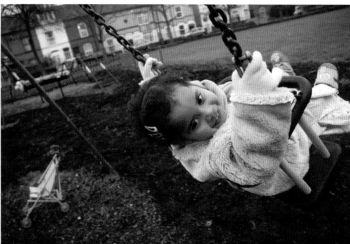

Samoa > Bournemouth 15,395 km

Indonesia > Nottingham 12,606 km

Daniel, 16 months
Daniel's mother, Princess: Daniel doesn't have a choice but I
think he is happy here. Back there in Nigeria, you know, you
really have these mosquitoes. Most of the time it makes him sick.
Here the only problem is the cold: having to dress up so heavily.
Sometimes he's very uncomfortable.

Nigeria > Glasgow 5,003 km

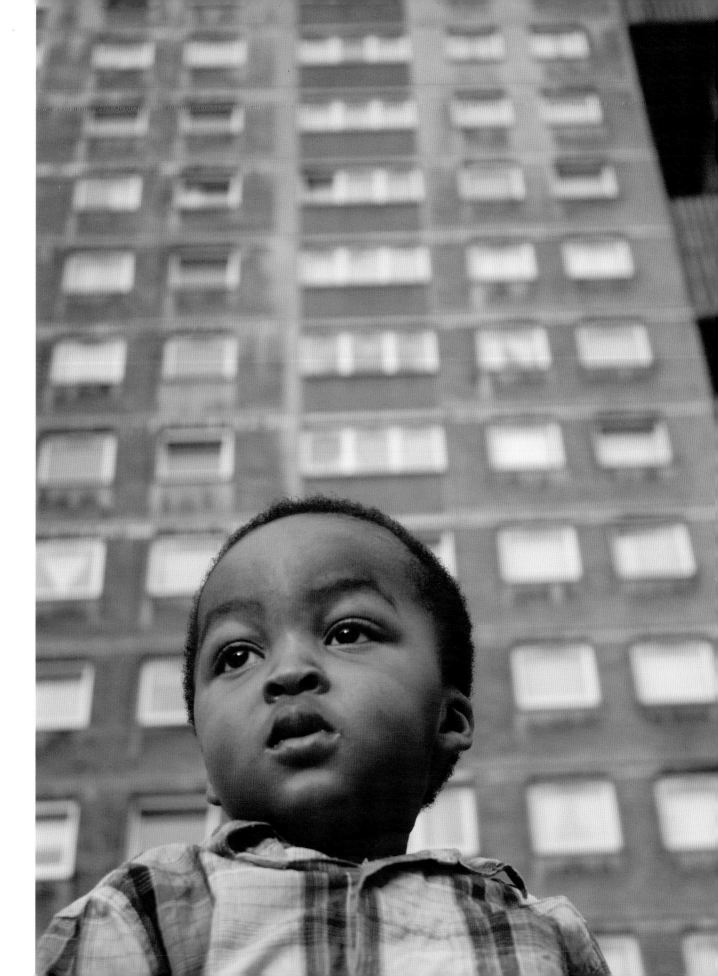

Mona, 11
It was so different and I asked my dad, "Why does they speak like that?" and he told me that it's a Scottish accent, and then I learnt Scottish accent from my friends.

Sina, 14
Teenagers here have more freedom. I'm not really allowed to go out: my parents, they have to know my friends before I can go out with them. I don't feel at home here. I've got no one, just my parents.

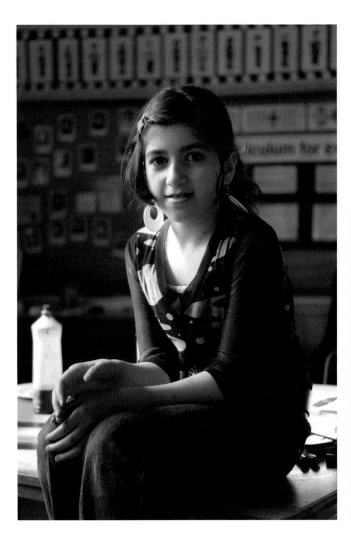

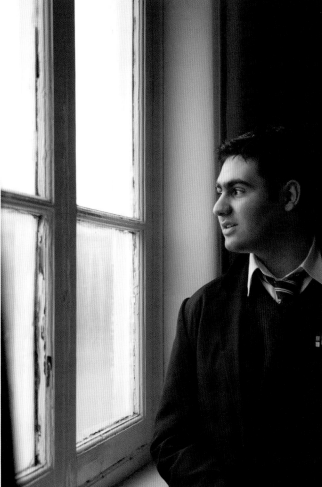

Jordan > Edinburgh 4,068 km

Iran > Manchester 5,062 km

Soobin, 13

I think it's a bit hard for my mum: she doesn't speak much English.

Jaga, 13

My mum was upset all the time: she never let the phone go, always spoke to my uncle and her friends. She was so unhappy she couldn't eat. Then she started to go to college and was busy studying, forgot about Kurdistan, changed to another person.

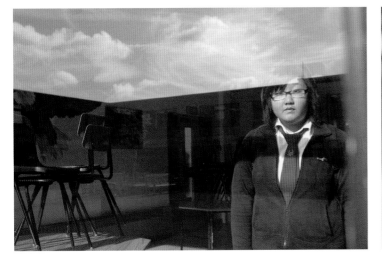

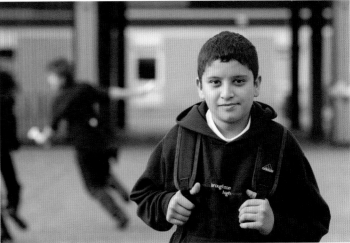

South Korea › Edinburgh 8,875 km

Iraq › Edinburgh 4,105 km

Rosesh, 11
At school in Nepal they hit us with sticks if we make noise—they were too strict. I was really surprised [when I came to the UK] because I thought they were going to hit me.

Kristof, 11
No good Hungary. Teacher bad, school bad. English good.

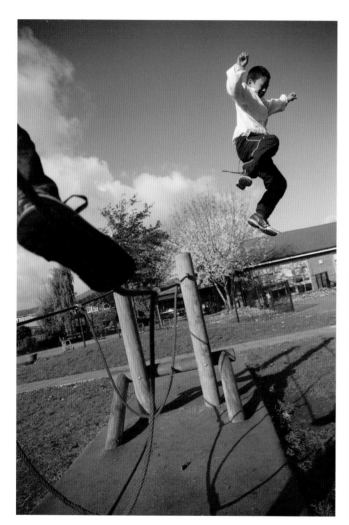

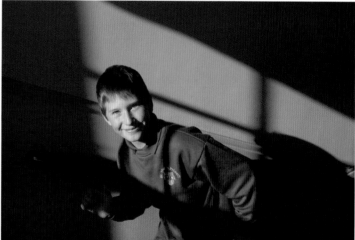

Nepal > Oxford 7,394 km

Hungary > Southampton 1,854 km

Ea, 15

You don't have to wear school uniform in Denmark, you can eat where you want and you don't have detention. Here in England they have many rules in schools. I like trying it but I don't want it for my whole education.

Indi, 15

In St Lucia people take education seriously—they don't joke about at school. If you don't go to college you can't get a job. Here, if you fail you can probably work in KFC.

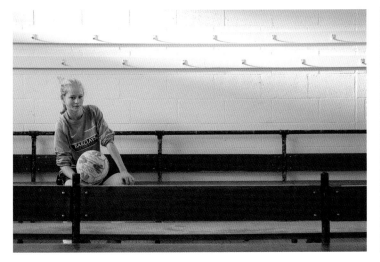

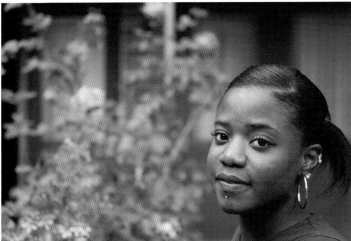

Denmark › Cambridge 918 km

St Lucia › London 6,628 km

Emmanuel, 13

There was problem of war and some people just lose their life easily so we decided to escape to another country. We passed Sudan and go to Uganda, running in the bush—my mum was holding me on her back. There were shots all over. There were air bombs.

In Uganda we lived in a refugee camp. It was difficult: no books, no facilities, school sometimes closed because of rebels killing children. It's not easy to get food and we have to collect water from ten miles away, put it on our head, walking all the way home without letting a drop fall.

When my dad told us that we are going to United Kingdom, me and my brothers were happy, jumping. We have to get interviewed and we have to get medicine and then on 3rd February 2006 we came all the way to the United Kingdom.

When we arrived it was cold cos it was snowing and it was freezing raining. I thought it was like that all the time. I found out it was not like that: you got four times, it changes.

There were some people that were showing us what the things are for, how you use them: the cooking machine, the heater.... They tell us the taps, that when there's a red circle on the top of the tap that means it's a hot one and when there's a blue one that's a cold one.

Life in UK was culture shock. Children not respecting: they walk around the street drinking, breaking windows, breaking into houses and they don't get any advice from their parents. Male, female doing everything, regardless of sex. Some of them dress with short skirts that will not be warm to them.

In Africa we didn't know what kissing was about. Then we came here, we seen people kissing on the road, in the bus station, town, in their office.... And we didn't have it in Sudan.

Sudan > Bolton 5,239 km

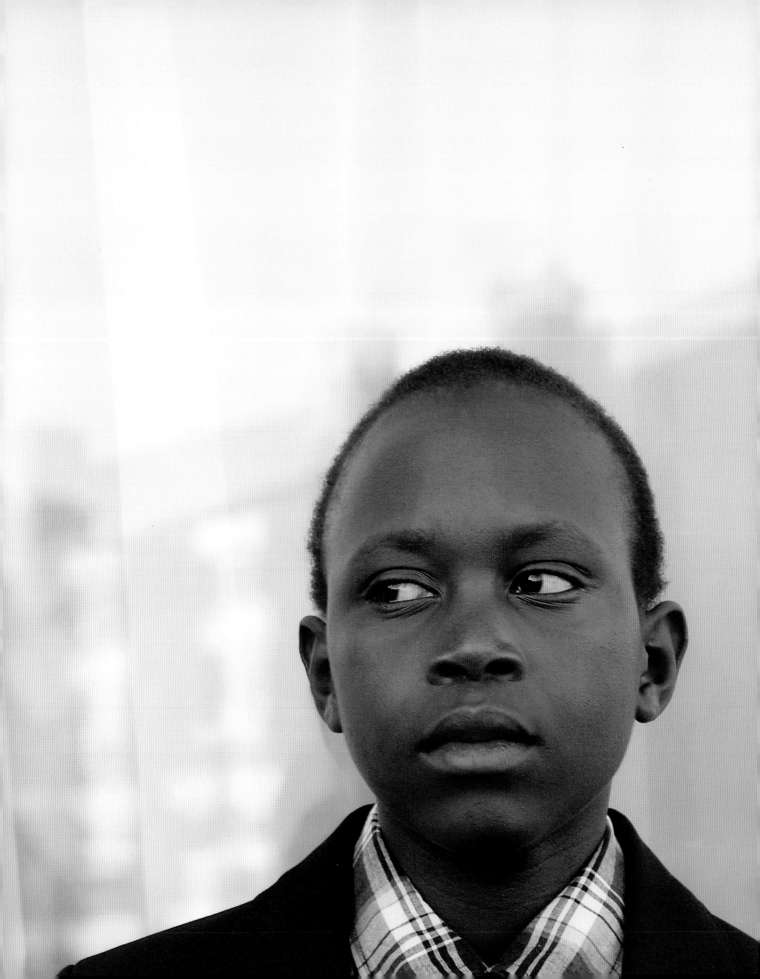

Collins, 10

[In Uganda] I spent my days playing with the dogs, watching my uncle cut a goat, which is quite gruesome but it looks good, chasing the chickens and climbing the trees. In London, I just stay home and watch TV.

Youssouf, 5

My favourite animal is lizard. I see them in Chad, climbing in houses and walls. If I play with them they just go away. [In London] I like playing with my toys. My favourite is police car.

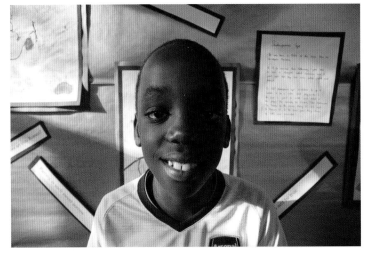

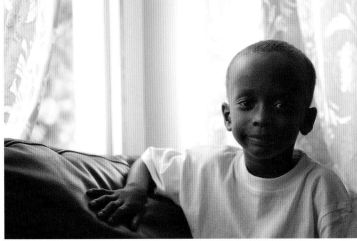

Uganda › London 6,686 km

Chad › London 4,772 km

Dalanda, 14
The way I play in my country is different: we play lots of games, singing and dancing. But here, not really.

Sumehra, 5
Cinderella is my favourite story. Cinderella is same Barbie like.

Guinea Conakry > Leeds 4,807 km

Bangladesh > Cambridge 8,116 km

Adi, 7
I like playing with my dolls. I have Chloe, Jasmine,
Minnie Boo and Jade....

Fiji > Tidworth 15,996 km

Chloe, 6 months

Chloe's mother, Alexia: When they're really little they just want
to play. It doesn't really matter for them where.

Andorra > London 1,340 km

Katie, 20 months
Katie's father, Kelvin: I think she can see the difference, when people from Singapore visit, as opposed to our friends from here. I think she can differentiate that these are people from different places.

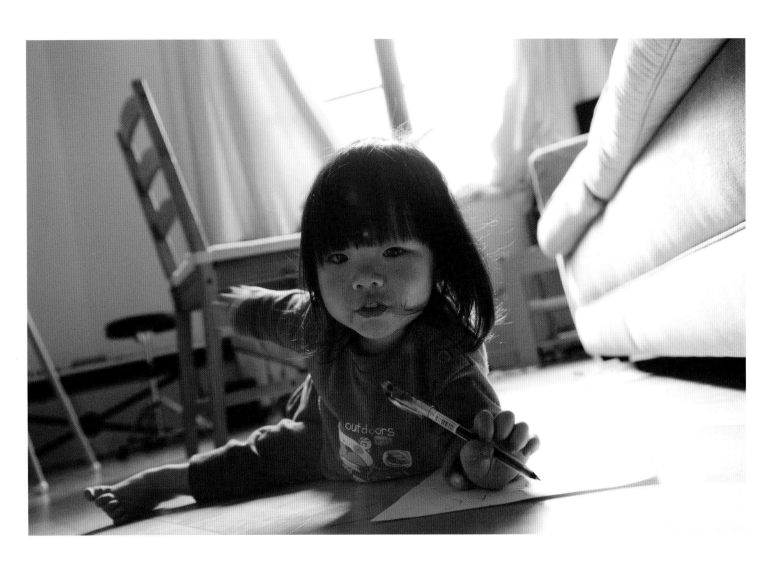

Singapore > London 11,025 km

Ventsy, 8

I saw someone in Tesco that's Bulgarian. I felt surprised:
I thought we were going to be the only ones.

Bodaya, 9

Every Saturday, Djibouti people come [to the community
centre] to meet each other, learn Afar language and Koran—
learn about themselves.

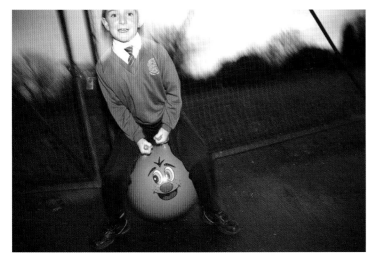

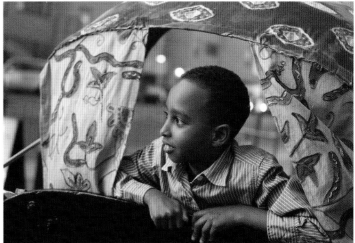

Bulgaria > Portadown 2,435 km

Djibouti > London 8,116 km

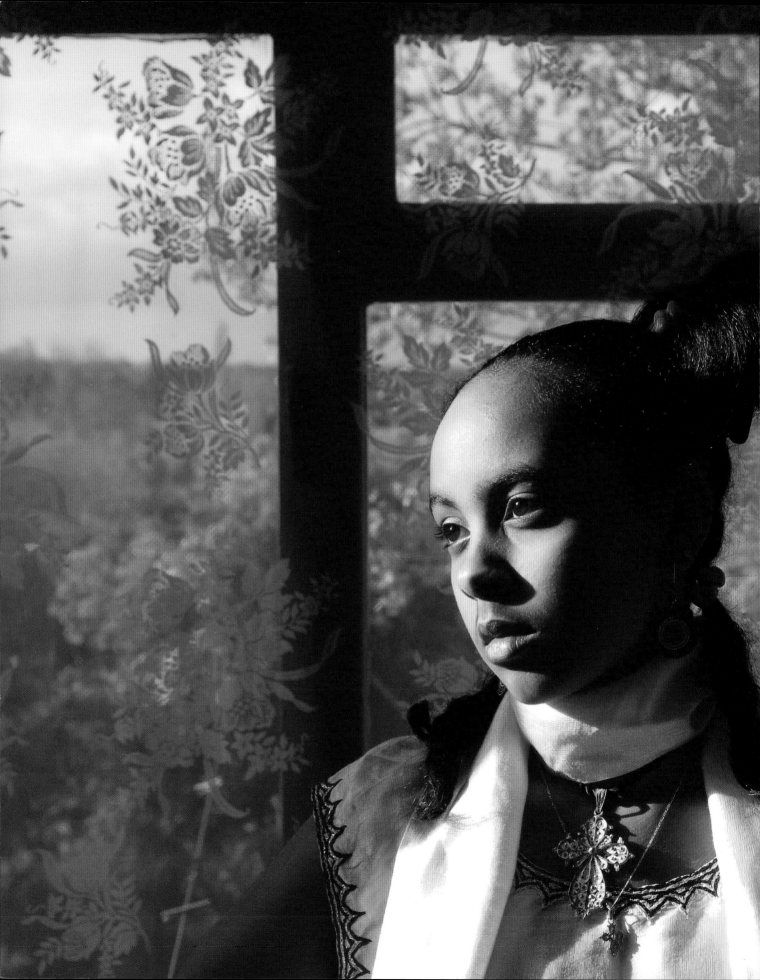

Elsabet, 14

There's two or three [Ethiopians] in my year and there's a couple more in the years below. We all know that we're Ethiopian just by looking at each other. We know that we're like family because we're from the same country, we're from the same background.

Ethiopia › London 6,413 km

Fatima, 13
Half of my friends are half Welsh, half English, some of them are completely Welsh. I'm the only girl there who wears a headscarf in the school. I don't really mind cos nobody brings it up or anything.

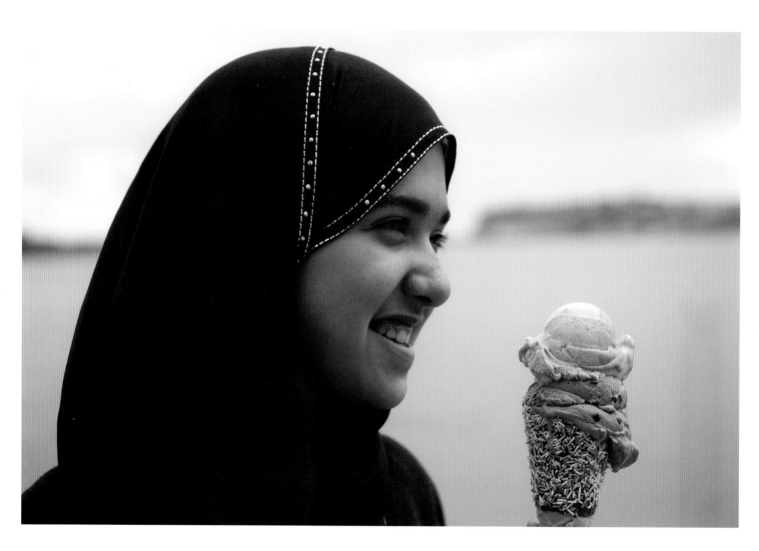

Kuwait › Cardiff 4,928 km

Arthur, 14

I now have friends over here and I can just hang about and be me, rather than staying indoors all the time like when I first came here.

Ken, 10

My friends, they're kind and helpful, they stick up for me.

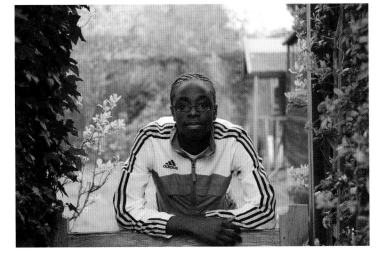

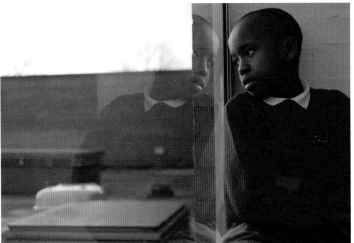

Bahamas > Harold Wood 6,704 km

Kenya > Birmingham 7,023 km

Akin, 11

I feel kind of Scottish cos people say to me and my dad we look like Scottish people, and that's what I like.

Angel, 12

People say I sound a bit Scouse. Except my dad, no one [in my family] speaks as good English as I do. I think it's easier to be younger and to learn English cos if you're older your mind is already blocked in with all the things you've learned from school.

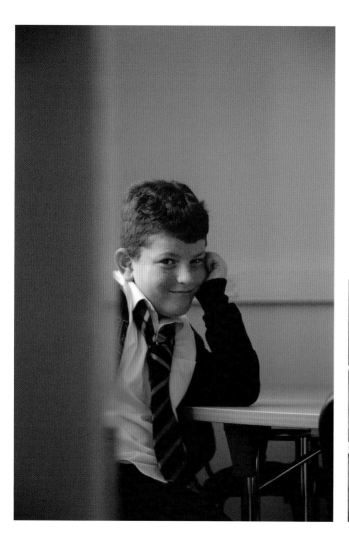

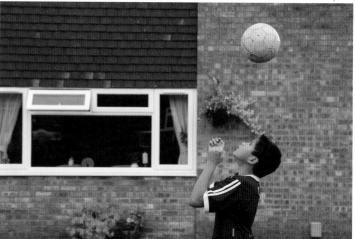

Turkey › Glasgow 3,358 km

El Salvador › Ellesmere Port 8,431 km

Fiona, 5
I've changed the way to speak. I use a funny voice now.

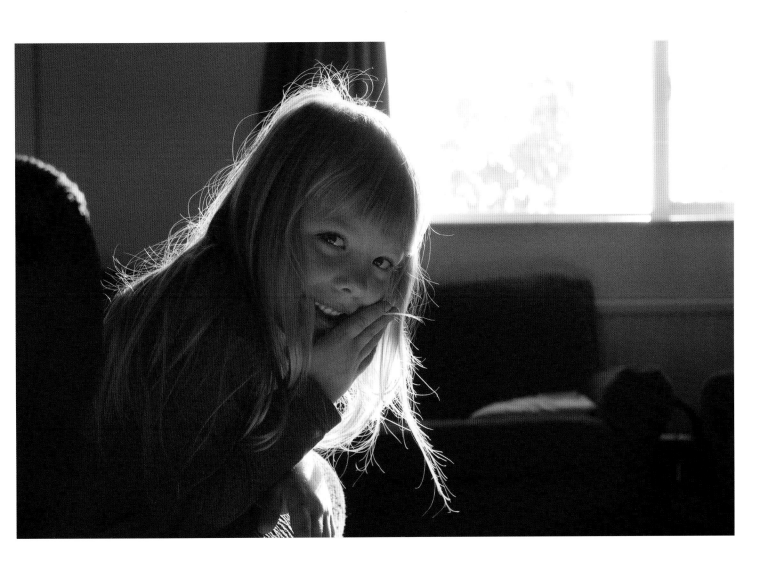

United States of America > Oxford 7,163 km

Melita, 15

We did have a lot of problems—it was mainly teenaged kids. It wasn't really because we were foreign or anything, it was because they were bored and it was easier to pick on the foreigners than pick on someone who's actually English.

It was mainly just throwing stones and eggs, and we had our windows broken a few times; it came to the point when we had to have a security camera installed. When you're a child, you feel, "What's wrong with me? Why are they doing this?" But as we grew up, we've just come to accept it. We're different and we're proud to be different: I'm proud to be from where I'm from. It's something I'll never hide.

Everything's been fine for quite a few years; right now I don't see myself as a refugee. I don't tend to ask my mum a lot about the war, because I know it's a painful experience for her to think back and it's quite hard for us to listen to as well. What my parents saw is something people should never have to see: my dad watched our house go up in flames; most of the men in the village got killed.

I've gotten so used to English culture and everything, like going to the chippy and things like that. It's just normal now. When people hear that I am a Muslim, it's weird for them, because apart from my name they don't have a clue that I'm foreign at all. I sound like a normal Derby person, and my family have never been strict about making us wear a headscarf.

A couple of years back we got our citizenship. That was a great moment for us because my parents had worried for so long that we'd have to be sent back; it meant we'd have a secure future forever.

Bosnia and Herzegovina > Derby 1,910 km

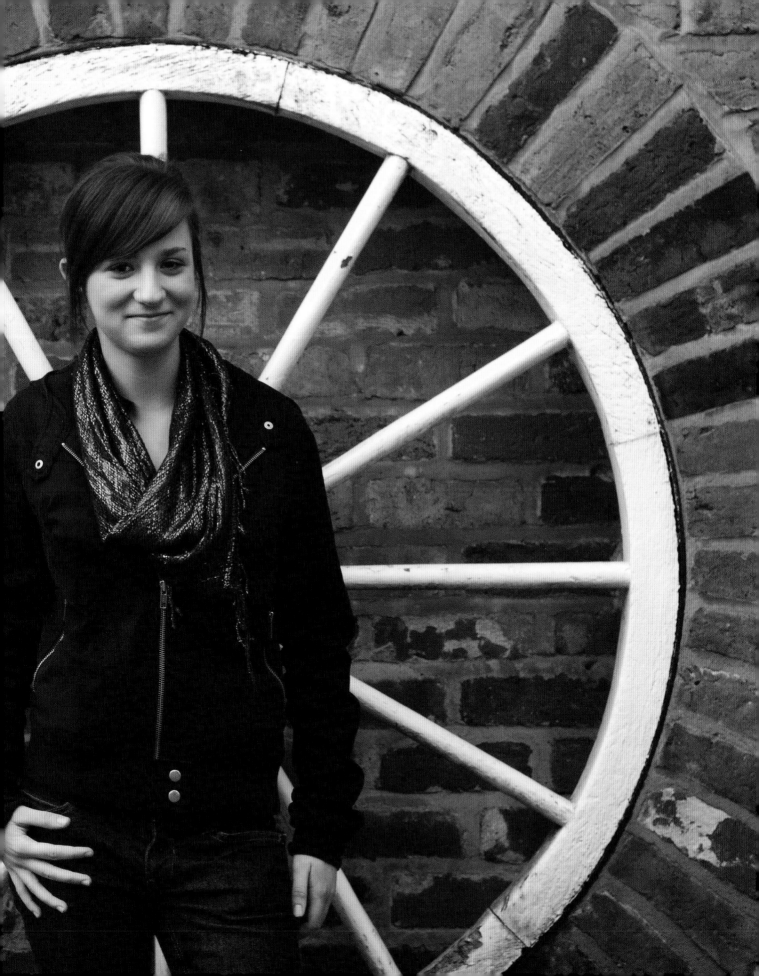

A Child from Everywhere
Being Here

Canada
Slovenia
Namibia
Cambodia
Oman
Norway
Benin
Maldives
Egypt
Congo (Republic of)
Kazakhstan
Antigua and Barbuda
Swaziland
Liechtenstein
Panama
Iceland
Sweden
Cuba
Argentina
Israel
Montenegro
Seychelles
Macedonia
Niger
China
Cyprus
Ireland
Guyana
East Timor
Lebanon
Guinea Bissau
Dominican Republic
Madagascar
Togo
Ivory Coast

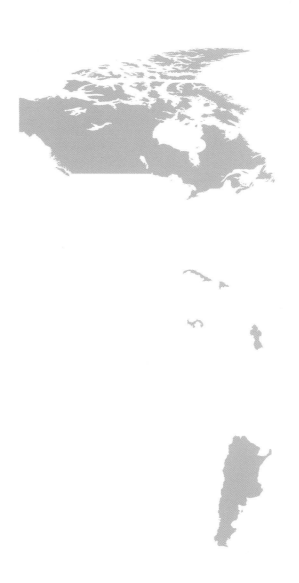

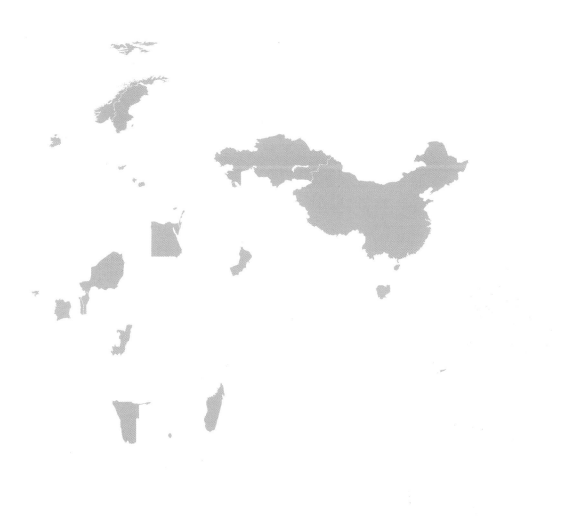

Eve, 8

I've noticed that Canadian people have bigger teeth than English people. And most English people have darker hair than Canadians. I don't know why I recognise that.

Tyra, 7

Slovenian people wear a little bit of make up and English people, they wear lots of make up.

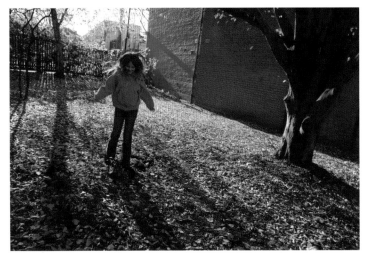

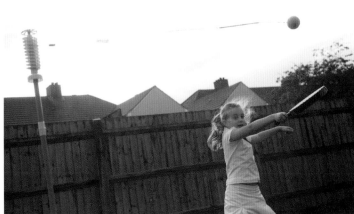

Canada > London 5,149 km

Slovenia > Bedford 1,606 km

Kingsley, 16

A kid my age back in Namibia probably wouldn't wear the earrings or the eyebrow thing.

Soprat, 15

There's a height difference: over there, around my age, they'll be quite small because of lack of nutrients. In England I got what I needed for my body.

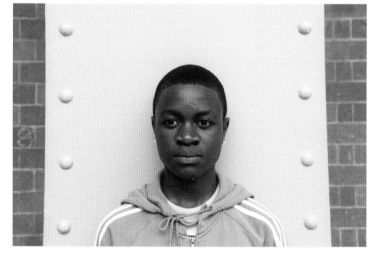

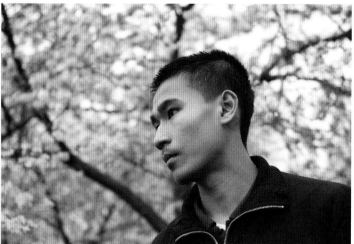

Namibia > Wellingborough 8,681 km

Cambodia > London 10,028 km

Amira, 11
People in Oman wear black dresses. I don't think they've ever seen these type of clothes. I don't think they've seen skinny jeans and things like that.

Ole, 8
People here look different. They have lots of different coats, and maybe different shoes, by the way.

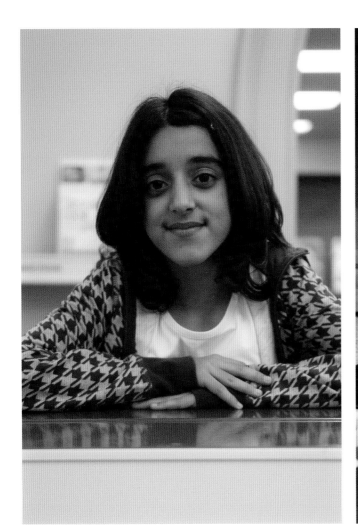

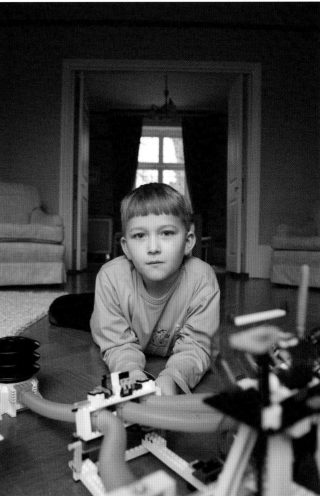

Oman > London 6,247 km

Norway > London 1,207 km

Leila, 5

There are only black people in Benin, no whites. In London there are white people, black people and orange.

Rayya, 8

This girl in my class says she wants to be this kind of colour, this kind of lightish brown. We tried to tell her that it doesn't matter about your colour, but she keeps saying, "I want to be a Muslim." She's a Christian, she has blonde hair, bluey green eyes and she has a bit of kind of peach colour.

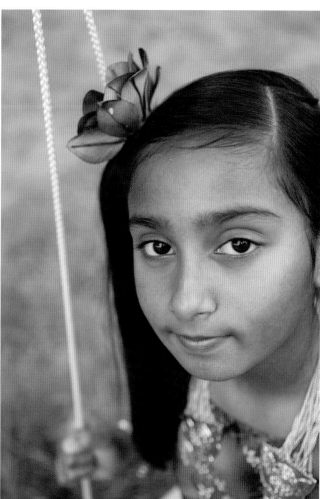

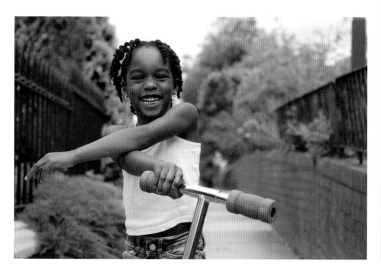

Benin > London 4,975 km

Maldives > London 8,875 km

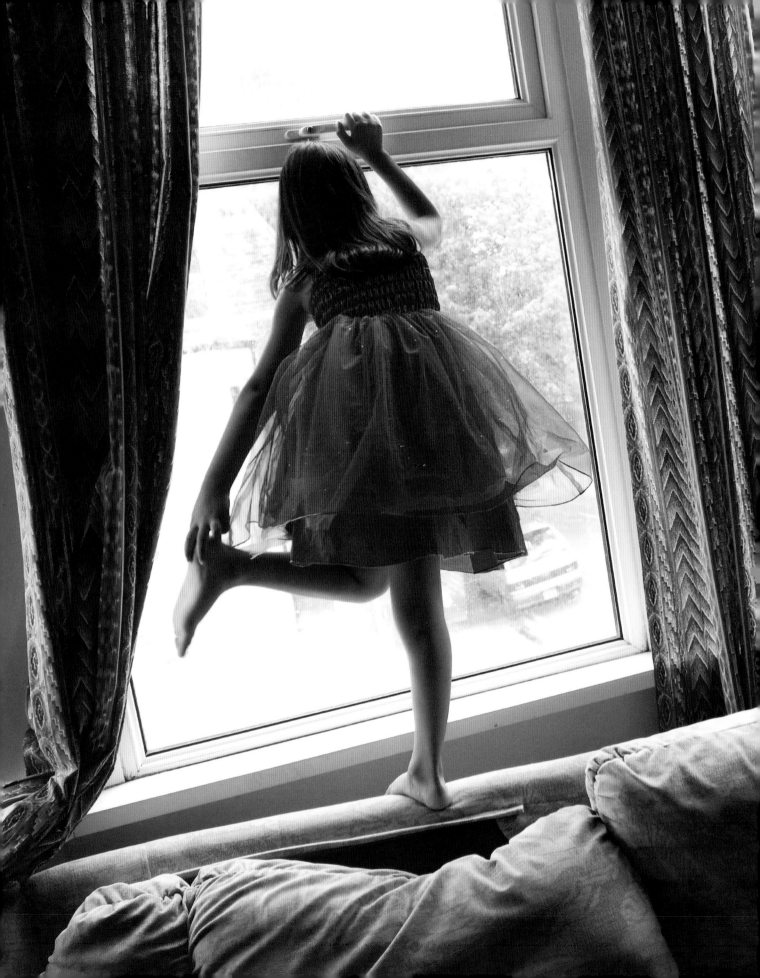

Nadine, 6

I have brown eyes and I have one tooth missing. I have, well, sometimes I have red hair—this bit and this bit—and I have brown hair and black hair. I'm a bit brown and I have a mark and I have some earrings. I look like a snail. And my tongue is red.

Egypt › Cardiff 4,081 km

Chris, 12

In Congo people eat pure food like *fu fu*, rice, *saka-saka*.
Some people here eat chips every day.

Munira, 12

I cook Kazakh food in England but it doesn't taste as good.
I think it's because of the ingredients: there it's fresh dairy;
here it's fat free and less calories.

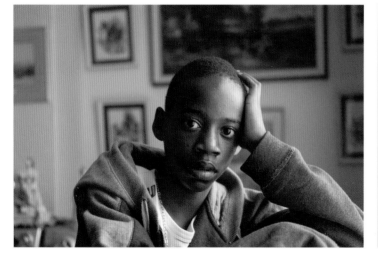

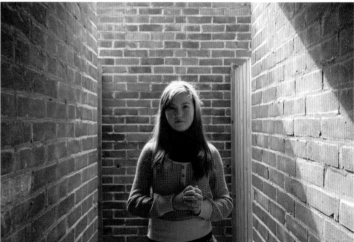

Congo (Republic of) › London 6,248 km

Kazakhstan › Richmond 4,858 km

Akeilah, 9

I'm a Rasta. It's not that easy because you like going to McDonalds
and getting the toys, but you need to eat a vegetarian or fish burger
cos you're not allowed to eat a meat one.

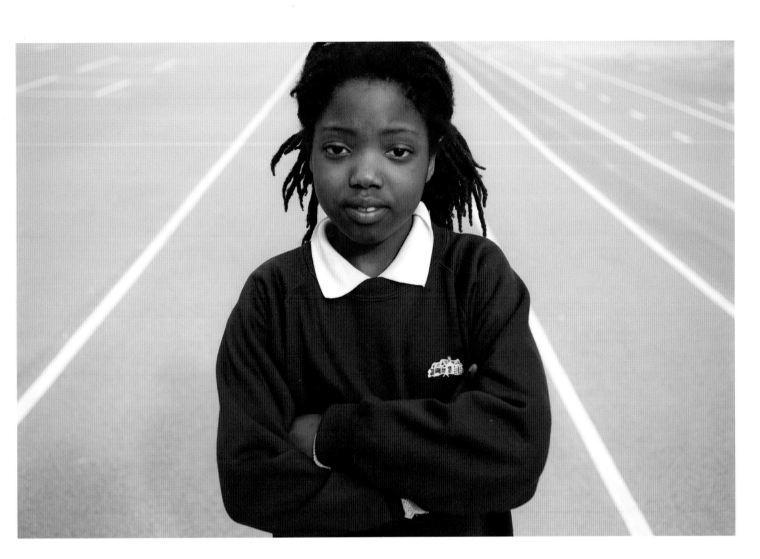

Antigua and Barbuda › Birmingham 6,394 km

Bola, 7
I like the pork from Chinese and I like the duck from Chinese
and I like Nigerian food and I like English food. Swazi food... eee,
I don't like it!

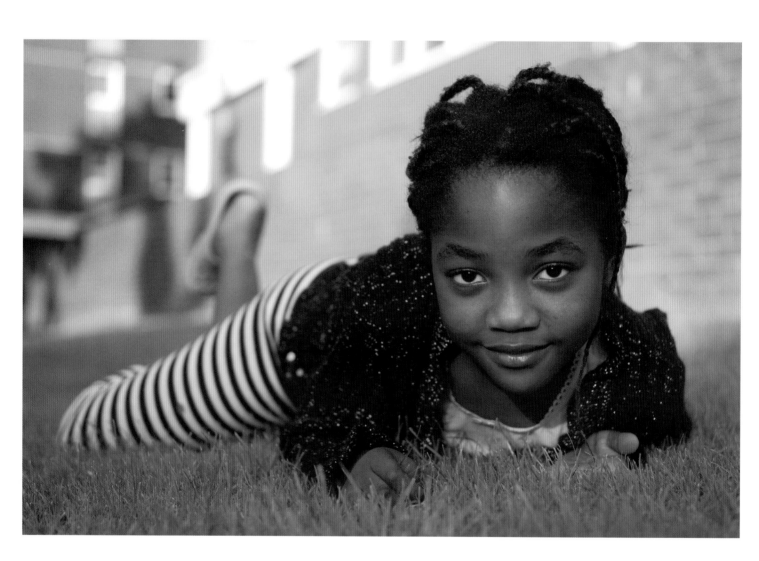

Swaziland › London 9,572 km

Selin, 9

The Prince of Liechtenstein always had a cake for breakfast and a cake for dinner. I bake with my Mum practically all the time: cup cakes, chocolate chip muffins, birthday cakes.... Sometimes I dream about a house that's made of chocolate cake.

Jairo, 6

Well I haven't tasted pie at Panama but I did here. I haven't tasted things which are really sweet and those are doughnuts.

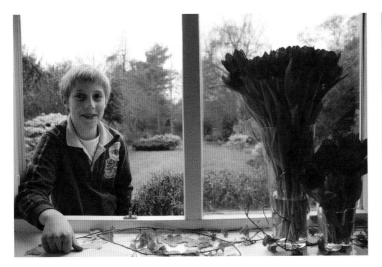

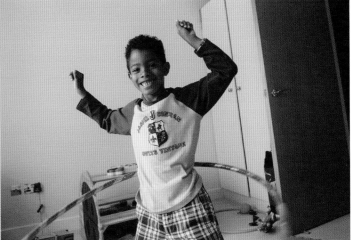

Liechtenstein > Maidenhead 1,216 km

Panama > London 8,280 km

Thorunn, 13

There's a snack that people eat in Iceland: it's basically a dried fish. It smells horrible but most Icelandic people love it. Once, when we'd moved here, I was on a school trip and I had a little bit of this dried fish with me so I started eating it and nobody that I was sharing a room with noticed. Then a few minutes later one of the girls in my room just said, "What is that smell?" They were absolutely grossed out that I was eating dried fish.

I think that if my friends from London were to come [to Iceland] they'd be surprised about the way people live their day-to-day lives. Iceland's such a small country—the population is 300,000 people—so I guess there's a lot more freedom there than here. I can go anywhere I want in Iceland without my parents worrying about me.

In Iceland it's very popular to wear wool sweaters: they're sold everywhere. It's completely normal to wear that on a daily basis. I think if someone would come to my school [in London] wearing that, people would think that'd be kind of weird.

You don't get many hours of light at all in the winter in Iceland. It's a very dramatic landscape: there's a lot of mountains and it's just very cold and dark. I think that's part of the reason why the fairytales are darker. In Icelandic fairytales there aren't a lot of nice little fairies or fairy godmothers or things like that, that people are used to here. There are a lot of trolls or ogres; typically they live in the mountains and they eat kids. And there are a lot of invisible elves living inside caves that like to do pranks on the humans. The tone is darker—they don't always end well.

Iceland › London 1,448 km

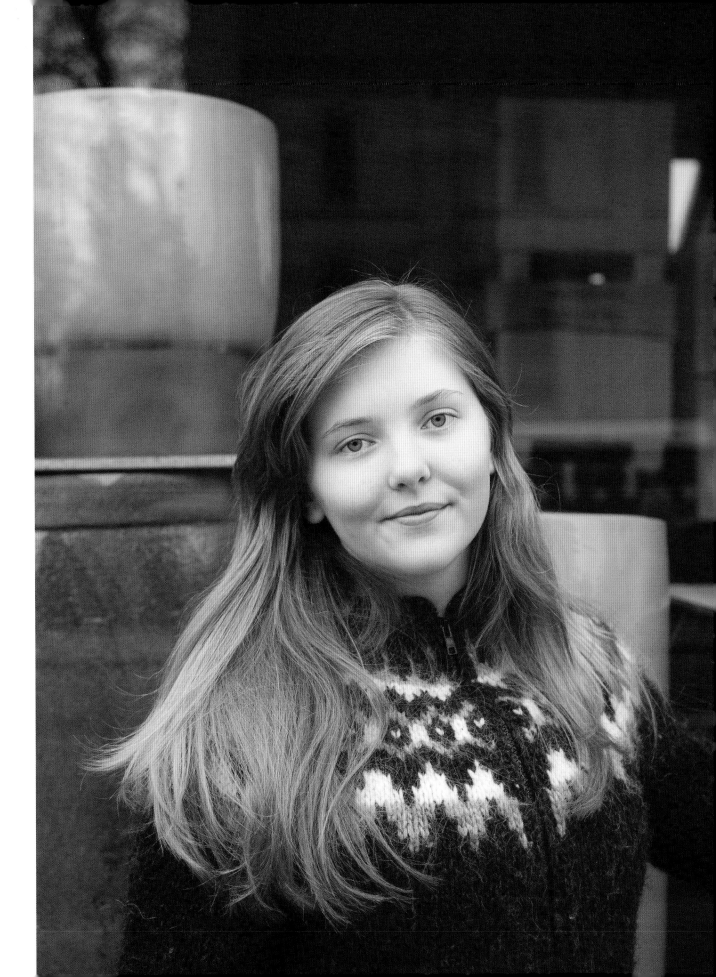

William, 8

You can draw in every single country, and you can sing and you can jump, so I think Swedish people and English people are quite the same.

Yunior, 11

Cuban people dance better than English people. There's Rumba, Salsa…. At school they put on a disco for the kids to dance, play games and win prizes. I won for dancing the best and limbo.

Sweden > Cambridge 1,420 km

Cuba > Isle of Wight 7,179 km

Sofia, 10

People are happier here and they're much more polite. People there sometimes aren't very happy because they're quite poor.

Guy, 10

In Israel they used to shout a lot. It's quieter here.

Argentina › Belfast 11,340 km

Israel › Truro 3,951 km

Anja, 5
What I like about London is ponds and playgrounds. And ducks.

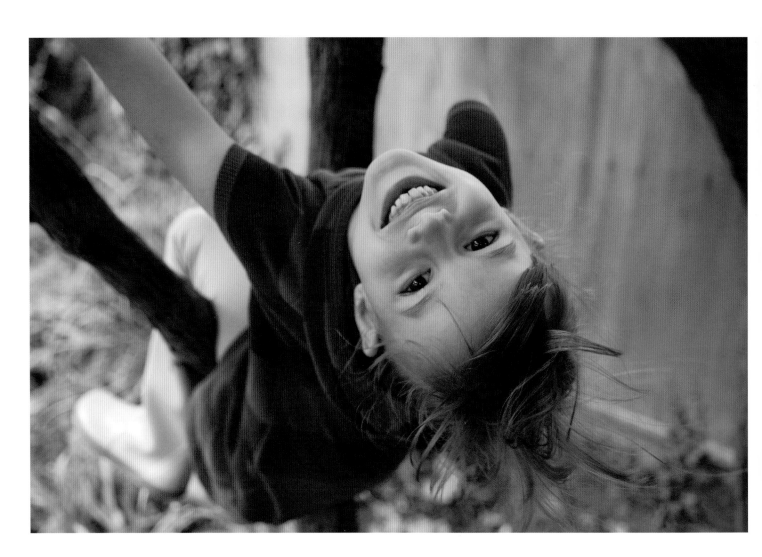

Montenegro › London 2076 km

Carol, 16

The Seychelles is like a tropical paradise island you could say.
They got nice waterfalls and beach and the sunset. Here, they got
the shops. Basically I like the shops. I was amazed with the shops.

Sara 12

Mostly I now go shopping because I'm older but I miss the
time where I can play hide and seek out in the fields with my
friends—it was more free and it was more safe in Macedonia.
Sometimes I get kind of tired of shopping because it's a bit
more grown up and I want to still live the life of a little child.

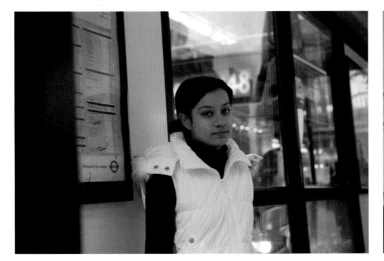

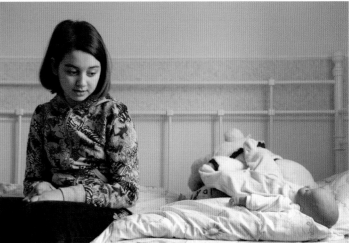

Seychelles > London 8,514 km

Macedonia > London 1,409 km

Boubacar, 14

In Niger they say it's a woman's job to clean. My friends from Niger would be surprised if they came here because they will see that a man as well can do the same thing. I like that—you can give your mum and your sister a break.

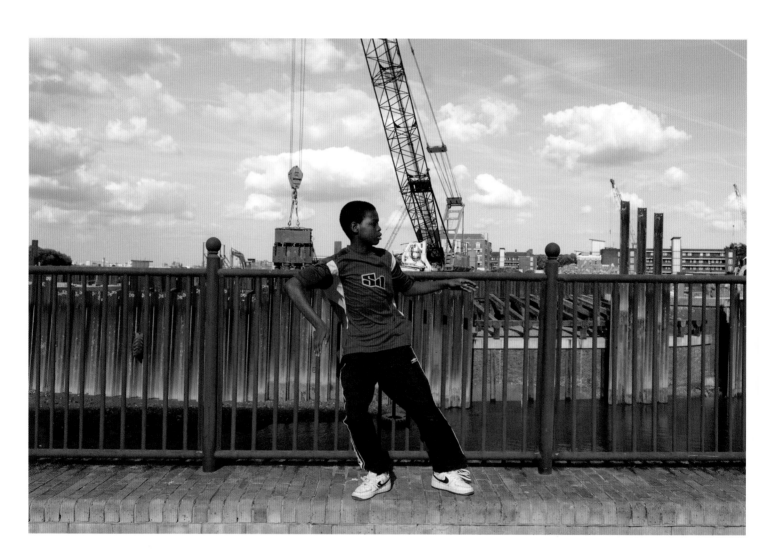

Niger > London 4,348 km

Zifan, 16

Chinese people are never late. My father, he don't waste people's time. He taught me at home: don't be late, it's not good. Every time my friends call me to come eight o'clock, I come eight o'clock or before, never after. My friends [here] are always late: thirty minutes, one hour or two hours. Then they always say, "Sorry I'm late." I can't be like that.

Chris, 16

I think there's a lot more humour in England and there's a lot more characters. Cypriot people can all tend to be quite similar in a way. They're always trying to keep on top: the way they look, their appearance, what they do. But they're also, I think, more friendly.

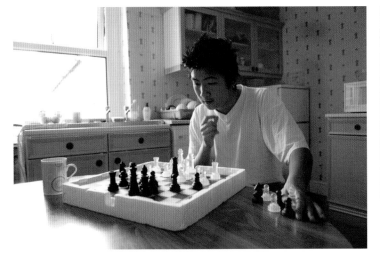

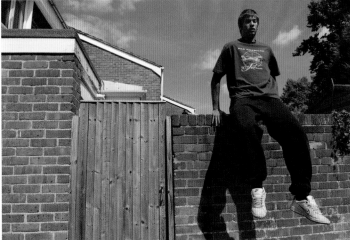

China > Cardiff 9,866 km

Cyprus > Amersham 3,549 km

Matthew, 15
You're very to yourself over here, whereas over in Ireland you'd know everyone who lives down the road and up the road.

Samuel, 15
Cambridge is not really that fun, it's a bit boring sometimes. Guyana is more exciting: there's people in the road all the time; there's always something happening.

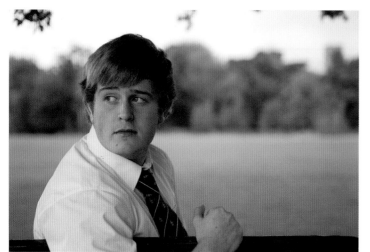

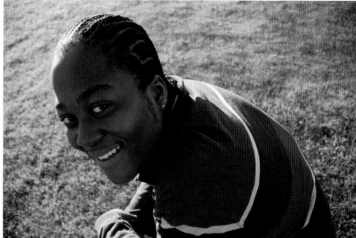

Ireland > St Albans 286 km

Guyana > Cambridge 7,336 km

Nicson, 16

Even your neighbour—you don't even know who is your neighbour. But in my country, the neighbour is your first family.

Rabie, 15

In Lebanon the neighbours eat with each other: all the people is brothers and sisters. Here not all the neighbours speak with each other but there is something beautiful: people speak with you in a nice way. They can't be mad very fast. They don't fight, they are peaceful.

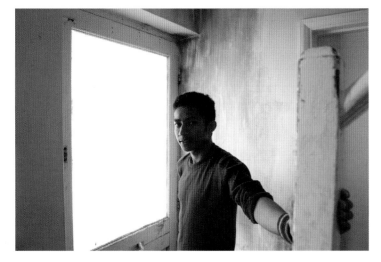

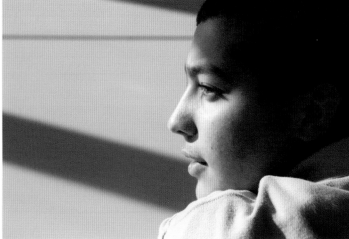

East Timor > Oxford 13,302 km

Lebanon > Leicester 4,010 km

Anax, 13
Not much work to do there, not much jobs. Some people haven't got enough money for food. But it's not like some countries [where] you got to find the food in the bin. If I have food and you don't, you come and ask me and I give you food.

Kabir, 15
Everything is in order compared to the Dominican Republic. [This] is a very developed country and what you get is a lot of opportunities to do anything you want: a lot of chances to improve your life.

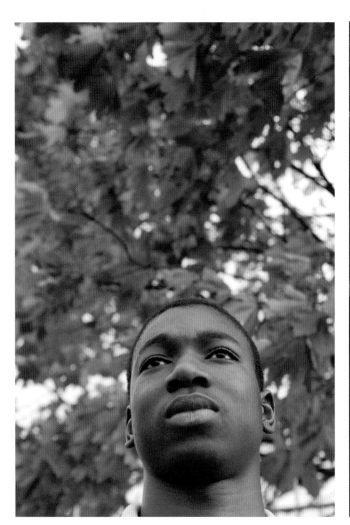

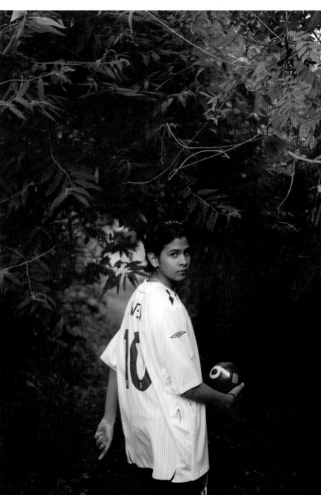

Guinea Bissau > Cardiff 4,766 km

Dominican Republic > London 6,787 km

Dickerson, 15
Even though their technology isn't as advanced as ours, they are still able to cope with life and still able to get by. Whereas here, even though we have all the technology, there are still some people who struggle with life.

Larissa, 16
News reports were really different. Normally, in Togo, the news report was just one person sitting there telling you about what happens in the country. It was really subjective. But the news here is pretty much objective. You just have to work it out for yourself—they don't tell you how to think about it.

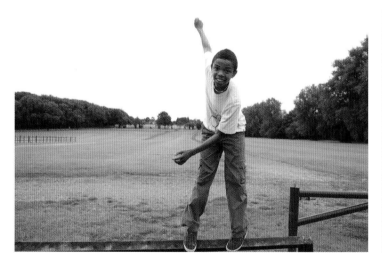

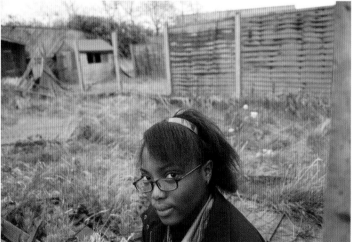

Madagascar > Newcastle 2,339 km

Togo > London 5,132 km

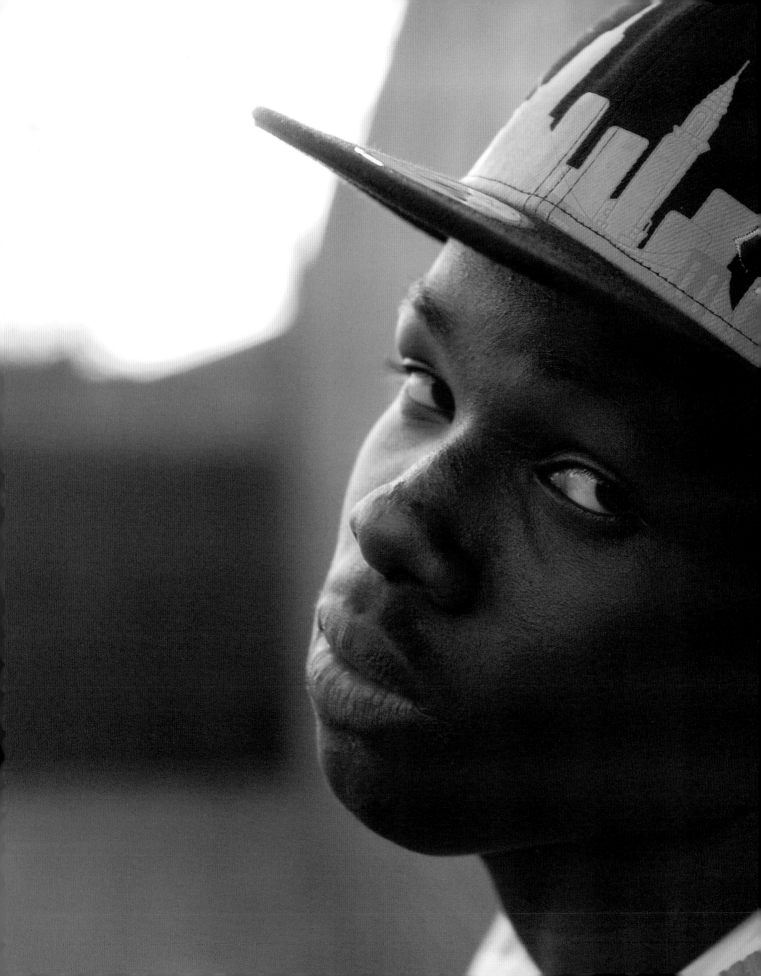

Inza, 15

When my parents were telling me, Inza, you're coming to England, I was so excited: I thought England was going to be some big thing for me, I thought England was going to be paradise. But it's just a little country, it's a normal country like every country in the world. The houses are nice and everything, but there's no big difference.

In Abidjan where I lived, I knew all the people down there, so there ain't nothing going to happen to me. In Africa, if you see anyone walking around, you just say hello. But in England if you see anyone and say hello, they will not say hello back—they have to get to know you properly. When I arrived here I was saying hello to everybody, but they wasn't answering me back so I stopped.

Here, age 12 you're already in a gang, and age 15 you're already making a crime. But I'm 15 and I am not doing that stuff—my mum raised me properly. I miss the free life in Africa. Over there I can go out at six o'clock in the morning and I can come back at one o'clock in the night. Safe, safe, nothing going to happen to me. Here, already at seven o'clock it's getting dark and if you go out somewhere that your parents don't know, you can get stabbed. Too much crime on the streets here.

If I met other young people in Africa who wanted to get out and come here I'd say, true to say in England there's a lot of money—in Africa there's not a lot of money. But Africa's a lot of fun and if I was you I would stay.

Ivory Coast › London 5,124 km

A Child from Everywhere
Looking Back

Australia
Romania
Mauritania
Malawi
Vanuatu
Equatorial Guinea
Comoros
Dominica
Vietnam
Kiribati
Serbia
Brazil
Honduras
Mozambique
Senegal
Russia
Finland
Monaco
Angola
Botswana
Azerbaijan
Turkmenistan
Croatia
Belarus
Bolivia
Afghanistan
Sri Lanka
Germany
Paraguay
Moldova
Lithuania
Gambia
Austria
Grenada

Greece
Myanmar
Malta
Luxembourg
St Kitts and Nevis
Tuvalu
Kyrgyzstan
United Arab Emirates
Ukraine
Mongolia

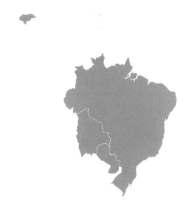

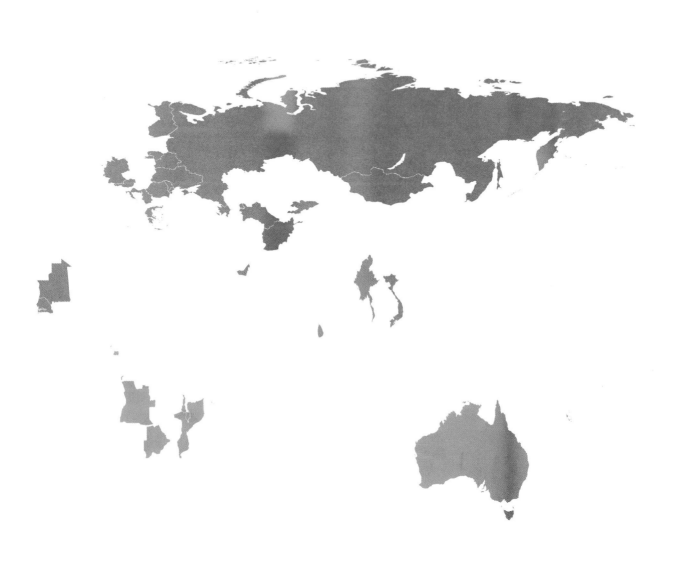

Sam, 6
There's something funny in Australia: the flowers keep
growing in winter.

Roberta, 6
The weather is different there: when the snow does come,
the snow is very, very come.

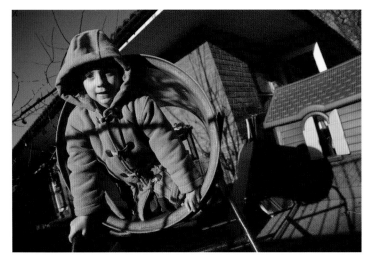

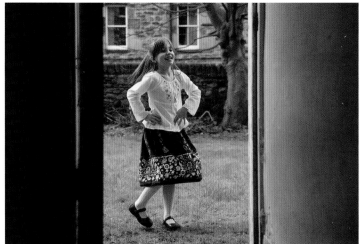

Australia › London 15,341 km

Romania › Edinburgh 2,234 km

Aïssata, 4
They don't have flowers there. I didn't see some flowers in Mauritania.

Alexander, 4
In Malawi I think I would see an elephant, a lion, a dinosaur and a tiger.

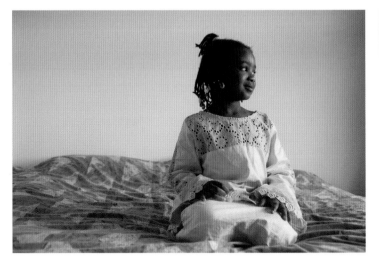

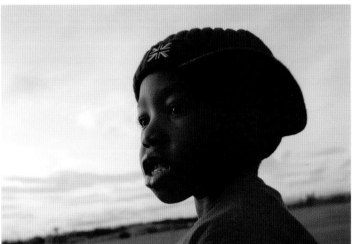

Mauritania > London 3,839 km

Malawi > Edinburgh 8,316 km

Cameron, 8

In Vanuatu I like setting a trap with my mum for pigs so we can cook to eat. We dig a hole and cover it with twigs and leaves, and when the pig comes it will fall into there. I would like to go back just for hunting pigs.

Armando, 12

I miss swimming in the rivers. When it rains, the stones are slippery and the water goes very high; more kids come to the river so it's more fun. We play tag in the water, hide and seek... Here most of the time I stay at home because of the weather.

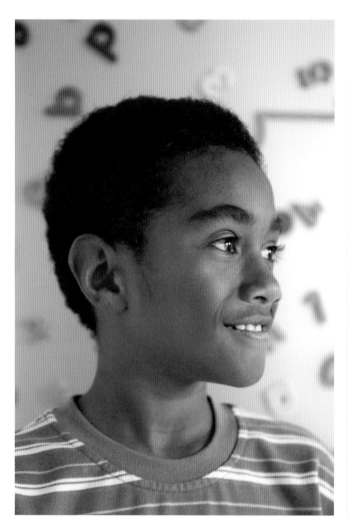

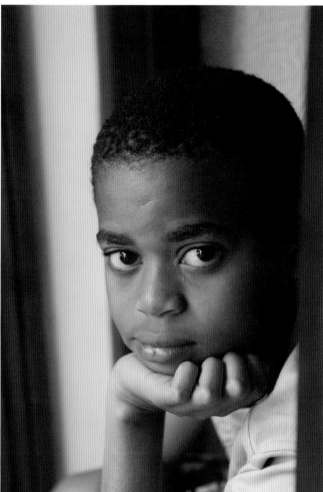

Vanuatu › Cardiff 15,707 km

Equatorial Guinea › London 5,918 km

Khelia, 3

Khelia's mother, Nadine: I'll make sure she goes there with me as much as I can and try to explain to her the culture—what we eat, everything about the country really so she's aware where she's coming from.

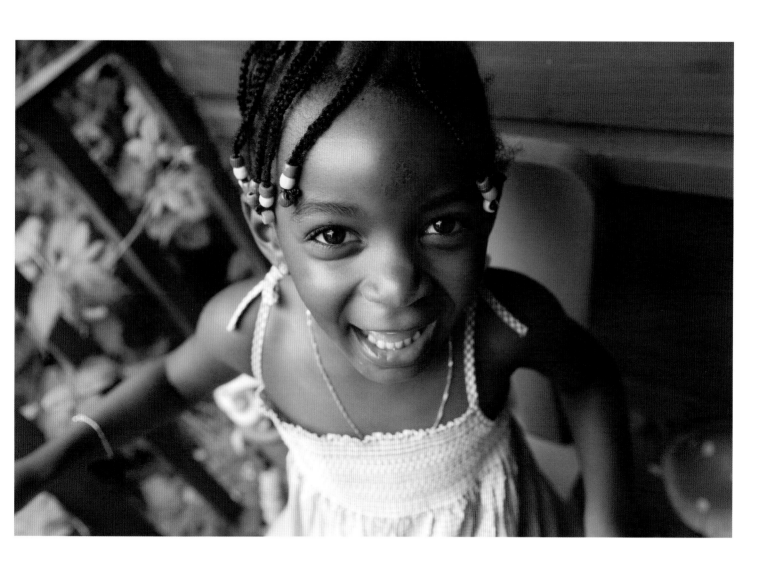

Comoros > London 8,640 km

Alissa, 11
In Dominica they eat mountain chicken, which is a frog that
lives in the mountain. When you eat it it tastes like chicken.

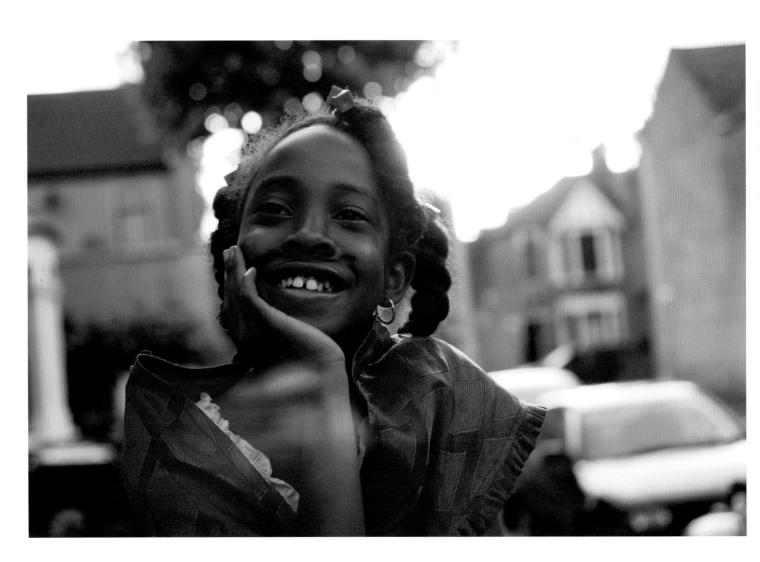

Dominica › London 4,042 km

Emilia, 7
In Vietnam people eat rice and fish and leaves.

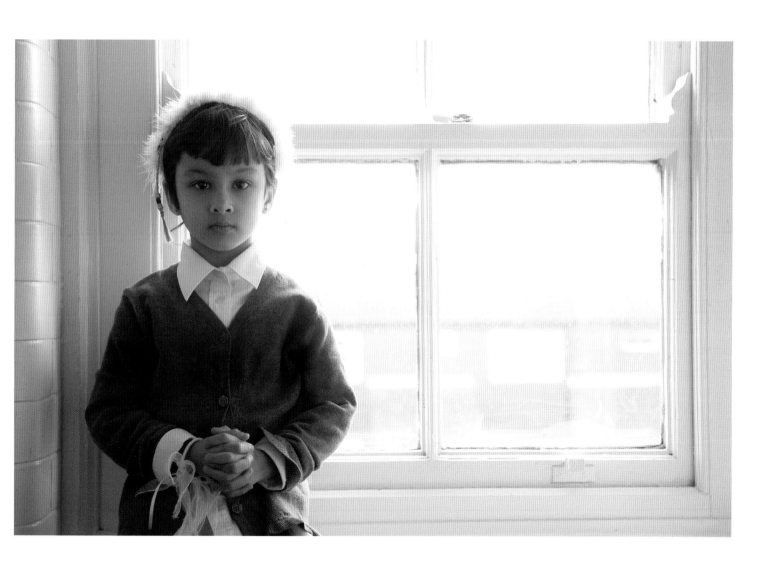

Vietnam > Leeds 9,903 km

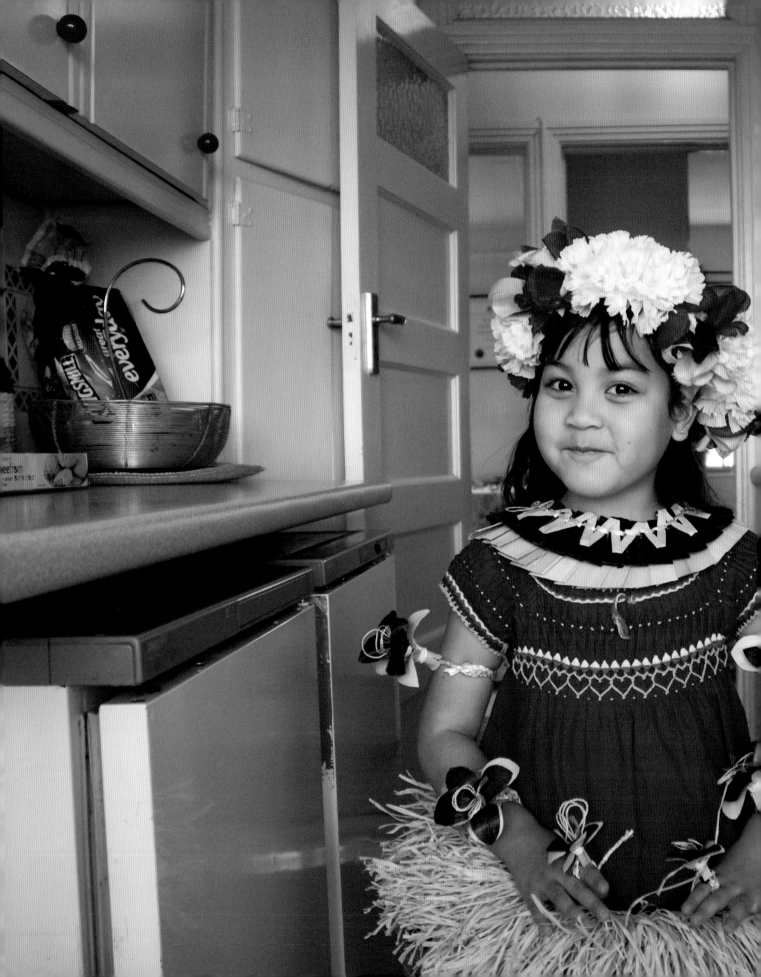

Isabella, 5
My favourite food in Kiribati is *te tou*. It's a kind of fruit—
you chew it but you don't swallow it. It looks like the
Victorian chimneys.

Kiribati > London 14,411 km

Mina, 12
My grandad told me lots of stories, they were very funny. He told me that there was bombing and he thought someone was in the house, but in the end it turned out only to be a cat. I like those stories, I always ask him to tell me them again and again.

Mauricio, 11
I remember this music when I was three years old at Brazil. I like the way they play. I don't really care what they sing, I just care what they play.

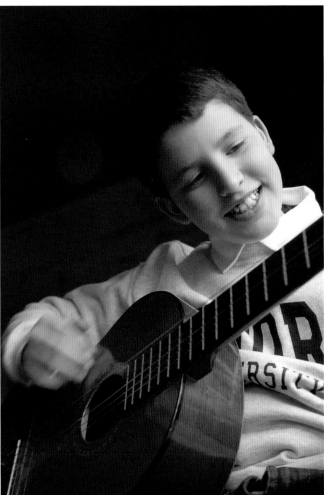

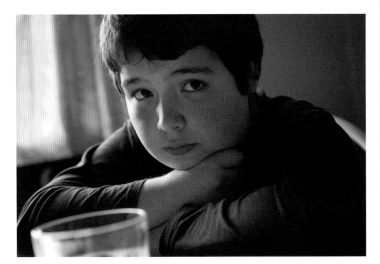

Serbia › Edinburgh 2,121 km

Brazil › Oxford 8,563 km

Gabriela, 8

This is a Honduran dress for dancing and I bought it in a little market there. They wave the bottom of their dress while they're standing. I like it a lot.

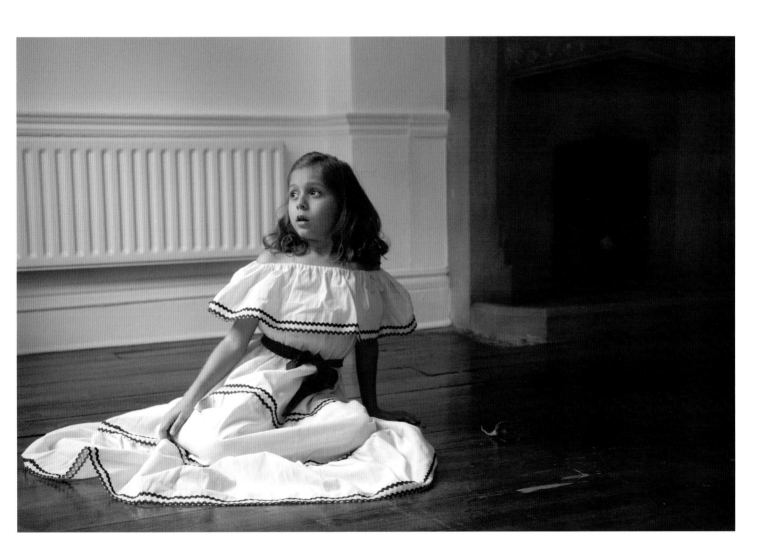

Honduras › London 8,170 km

Denise, 14
I'm proud of everything about my country cos that's where I'm from. Everything about it makes me feel very proud.

Khadija, 8
None of them do bad things. All Senegals are good, they wear clean clothes and everything.

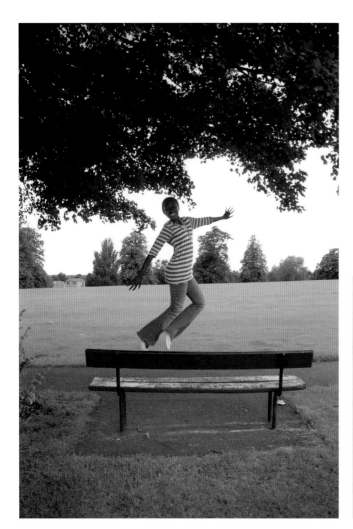

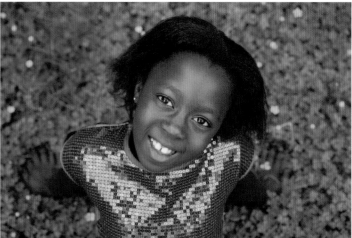

Mozambique › Croydon 8,845 km

Senegal › London 4,530 km

Ilya, 10

I am proud to be Russian because Russia is the biggest country.
If not for Russia, all of Europe and Asia would be German now:
Russia made Germany go away.

Alec, 4

[In Finland] they have ten million sweetie shops.

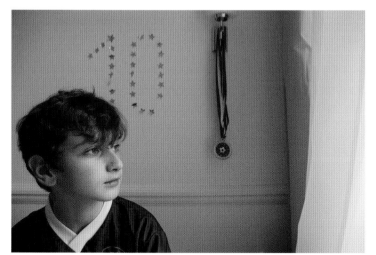

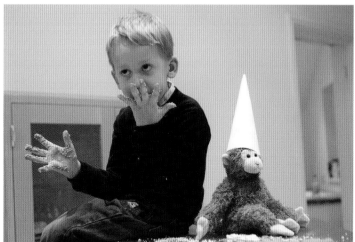

Russia > London 5,665 km

Finland > London 2,016 km

Elliott, 3

Elliott's mother, Laurence: It's a tiny country—they say it's the size of Hyde Park. I think there's only about 7,000 nationals, so not many passport holders. When I go through immigration I often get, "Ooh I've never seen one of those before, let's have a look at your passport!"

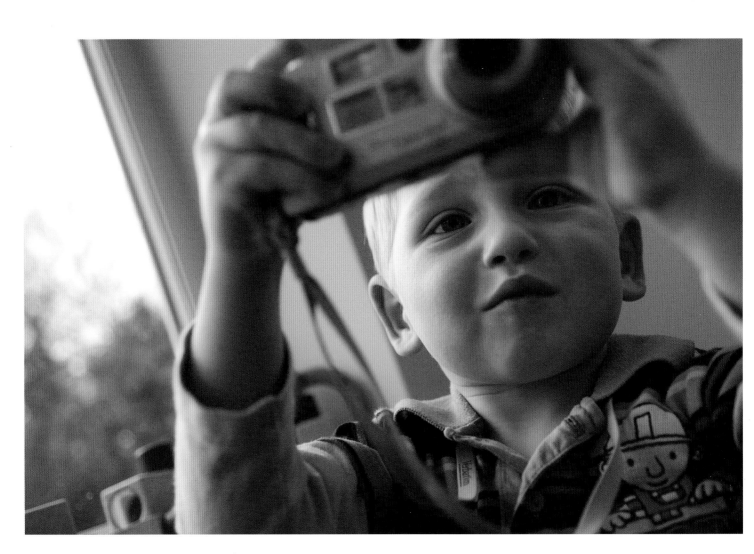

Monaco › Beckenham 1,409 km

Catarina, 14

Angola is a lovely place—I just wish people come from England would feel free to go there instead of thinking, "If we go to Africa we're gonna starve." That is not true at all. I just want to make people to know that in Africa there is actually food and we actually eat and we're healthy. It's kind of annoying when people show the bad part of Africa on TV.

Zoe, 11

My family in Botswana live in houses. Not like villages and huts—well-built houses.

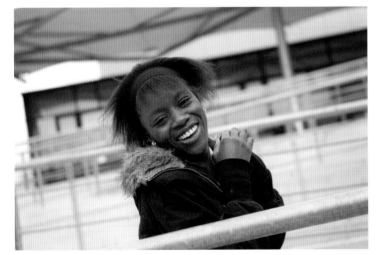

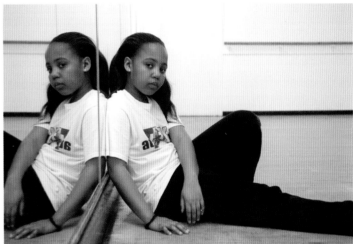

Angola > Leeds 7,689 km

Botswana > London 8,860 km

Fidan, 12

When I tell people that I'm from Azerbaijan, they're like "Where is that?" It may be a foreign country but they should know because it's on the map. I always show them but they can't even pronounce it.

I feel really happy to be Azeri because Azeri culture is a rich culture. Our language is good, our music's good—I have to say, it's got more rhythm than English music—our food's delicious… I love being Azeri.

But I only like Azerbaijan for holidays. I really like England for staying because I lived here more than Azerbaijan: I have more friends here, and my school. When I go there I mix up everything: sometimes when I talk to them I speak in English and they're like, "What you saying?" They see me like a different person: they all treat me nice, just because I come from London. That annoys me because I ain't different to them, am I? Just because I live in London, it doesn't make a big difference.

Azerbaijan > London 4,058 km

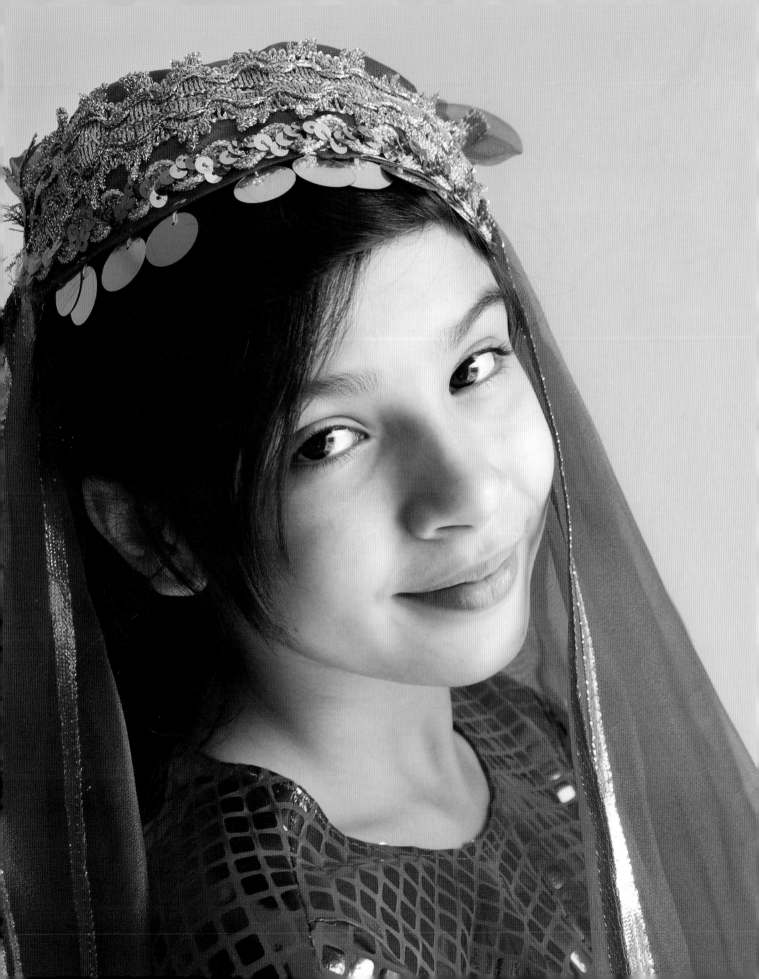

Mekan, 14
I feel bad cos no one knows about my country and I never met people from Turkmenistan in this country.

Srdjan, 7
My mum and dad watch the news here, but there's no Croatia stuff.

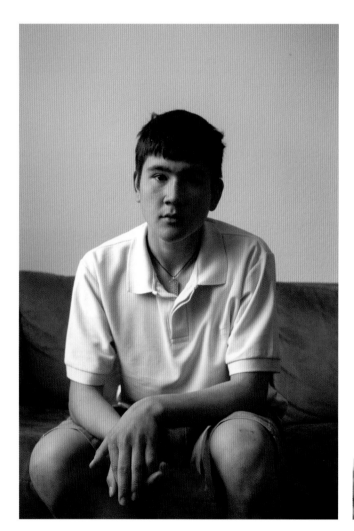

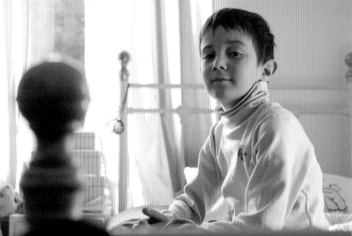

Turkmenistan > Barkingside 4,907 km

Croatia > Cambridge 1,705 km

Aleksei, 8

I tell them there is a country called Belarus. Well, they argue
all the time, saying, "No there isn't."

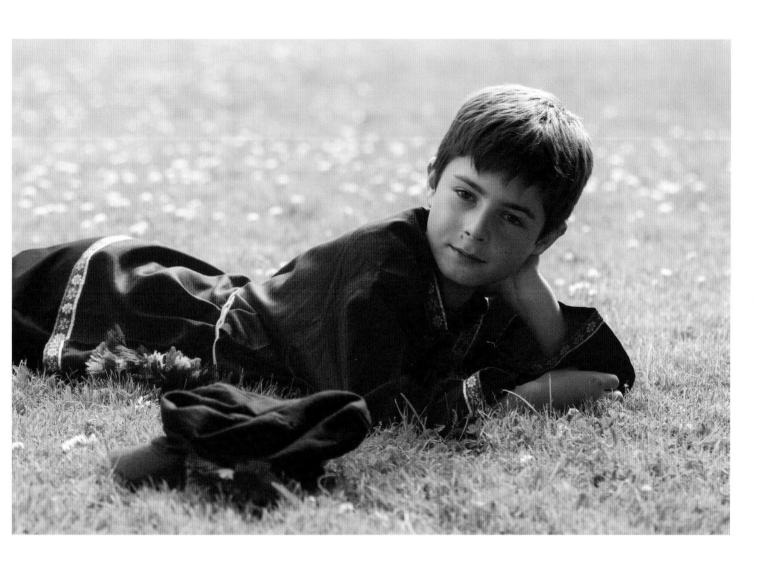

Belarus › London 2,100 km

Natalie, 10

I haven't seen my family for nearly three years. I can see them through Skype but I can't see them properly, like you're holding their hands, because you're not that near to them. You're across seas.

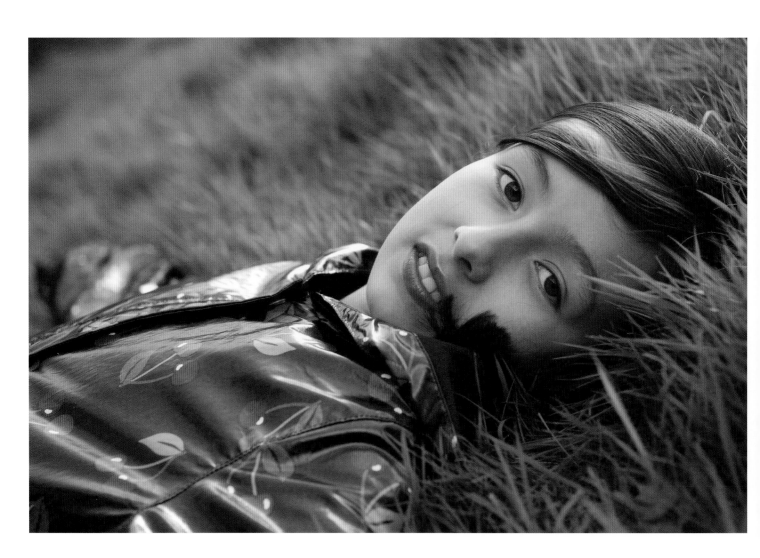

Bolivia › London 9,771 km

Sara, 10

When you miss someone, it's like they're dead because you don't think you're gonna meet them again. I really miss my family.

Rosan, 14

I remember Sri Lanka just a wee bit: I remember my school, my house, my dog, the garden, my friends. I would really like to see my friends, if they're still alive or not.

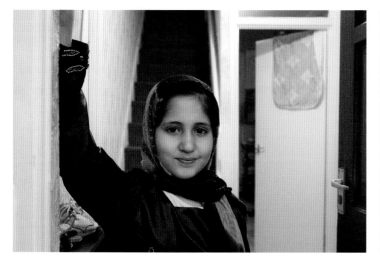

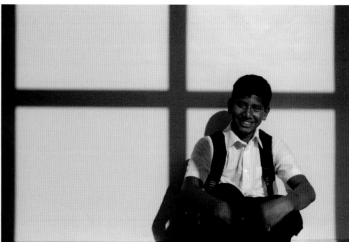

Afghanistan > Manchester 5,765 km

Sri Lanka > Glasgow 9,045 km

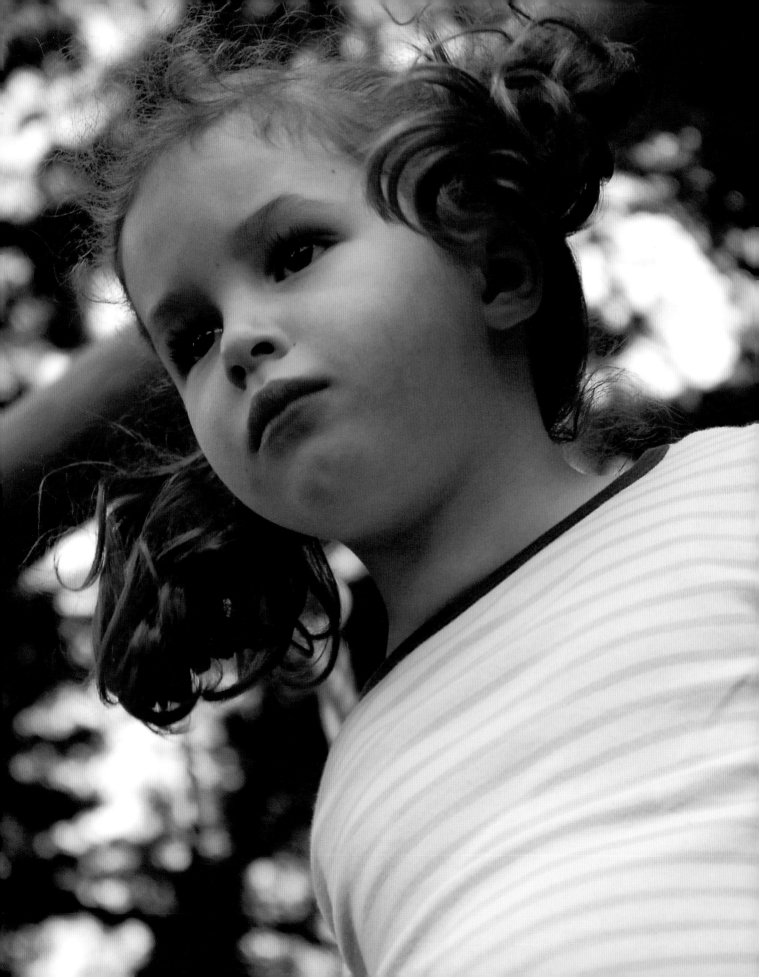

Johanna, 4
Sometimes Grandma and Grandpa cook me my favourite food, kohlrabi. It's white and you cook it and sometimes we growed it in the garden.

Germany > Windsor 1,012 km

Antonella, 12
What I miss most about Paraguay is my granny, my friends and dancing. The parties there would start at twelve o'clock at night and go on til four in the morning. [In London] I just dance in my room.

Madalina, 5
I miss my toy fox. It lives at my gran's house. And I miss my gran.

Paraguay › London 9,987 km

Moldova › Feltham 2,433 km

Lukas, 7
I dream about Lithuania—playing with my friends. I miss
Lithuania: my friends and my grandma. Nothing else.

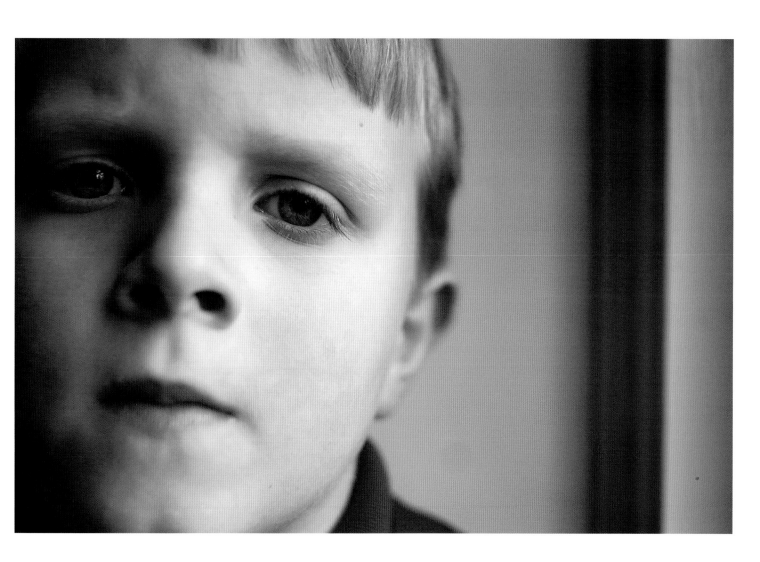

Lithuania > Belfast 1,786 km

Ensa, 8
I miss playing football in the Gambia.

Paul, 13
I miss the mountains. I would like to bring the mountains from Austria, but you can't do that.

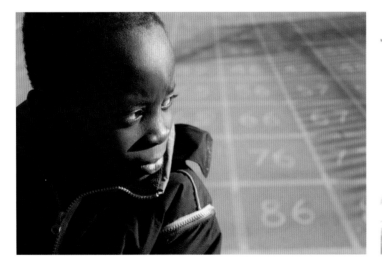

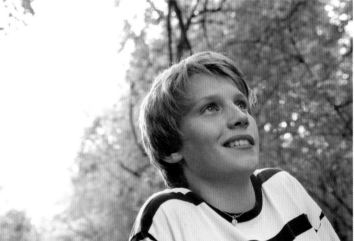

Gambia > Birmingham 4,611 km

Austria > Petersham 1,422 km

Anthony, 13

I miss the night times: when you go to sleep you can always hear crickets outside making really nice tunes. It's really relaxing.

Antonis, 14

If you entered my room, there's a great big Greek flag on the wall. It's where I come from: it's my culture, it's my people. I'd like to kiss the earth in Greece: it's wonderful to be there.

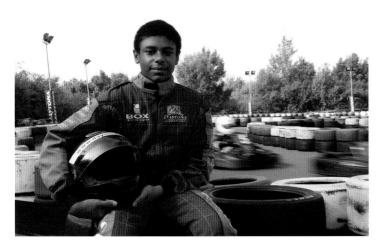

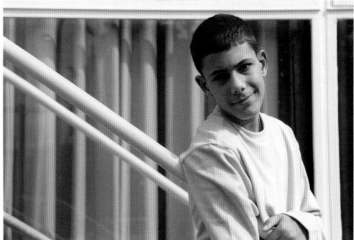

Grenada > London 6,833 km

Greece > Liverpool 2,569 km

Moe, 10
I saw the monks and the demonstration on TV. I know only that the regime in Myanmar is bad.

Myanmar > London 8,785 km

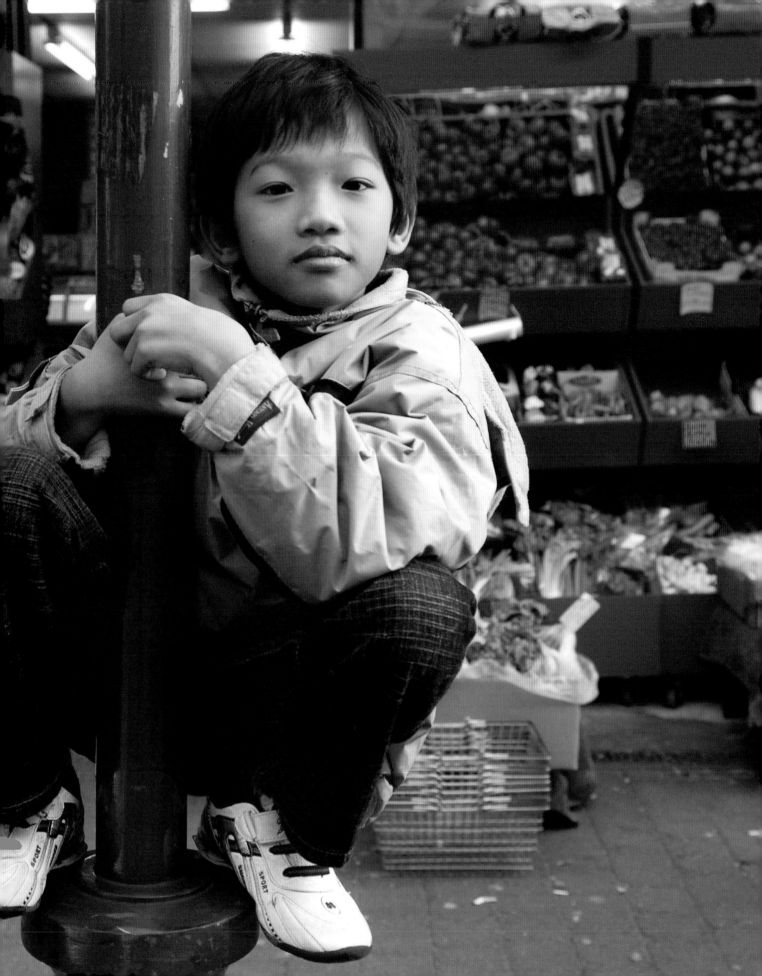

Damian, 13

I don't like to stay with one type of people—that's why I have a lot of friends which are different races. Malta, there's not really a lot of different types of people, there's loads of Maltese people, that's the problem.

Noemie, 15

Luxembourgish people are perfectionist. They're really strict and bossy. I think my parents are exactly the opposite of what a perfect Luxembourgish person is. They're way too tolerant for Luxembourg.

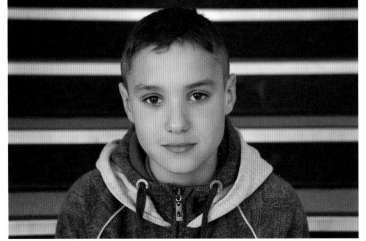

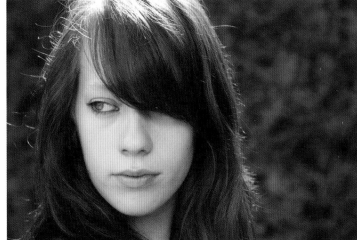

Malta > Cardiff 2,461 km

Luxembourg > Surbiton 841 km

Mark, 12

I've been [to St Kitts] once to see my grandad. When I was there, I felt that everyone was looking at me and my mum. Everyone there was all in jeans and stuff, and we were walking round in shorts and T-shirt and that, looking like tourists.

Juliette, 15

I spent a month in Tuvalu five years ago. The girl cousins were always like, "Can we dress up in your clothes? Can we dress up in your clothes please? Can we have this now?" And I was just like, "Oh, do we have to?" I ended up giving half my clothes to my cousins.

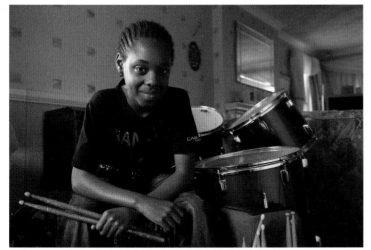

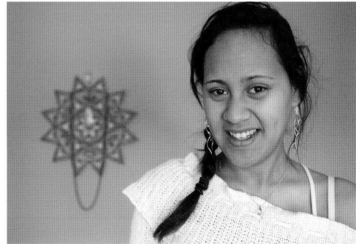

St Kitts and Nevis > Morley 6,428 km

Tuvalu > Alton 14,886 km

Aliya, 9
In the beginning, everyone was kissing me and I didn't know
what to do. And I didn't recognise half my relatives.

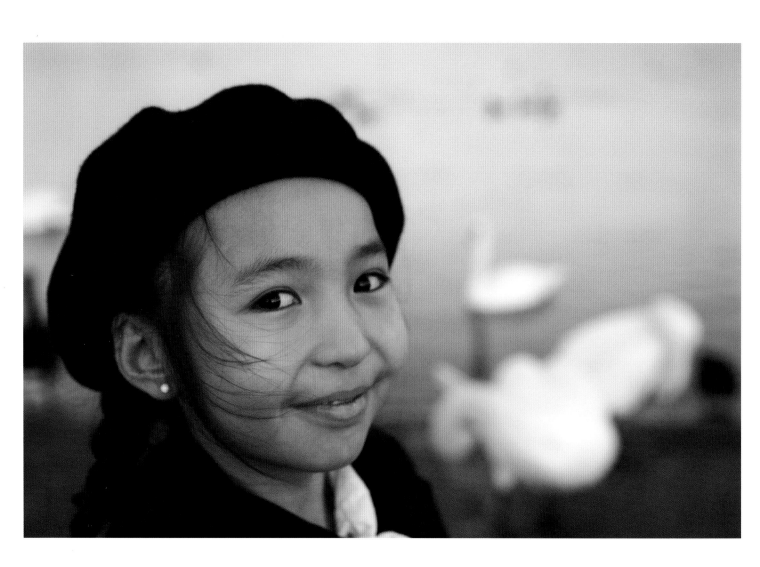

Kyrgyzstan > London 5,780 km

Nada, 8

I used to have friends there but then they forgot me. They're different because I travel and they don't, they stay in the same country. They know the weather, they know everything there, and I just know here.

Alice, 6

I think nobody will remember me, of my friends, because I look different when I'm big than when I'm small.

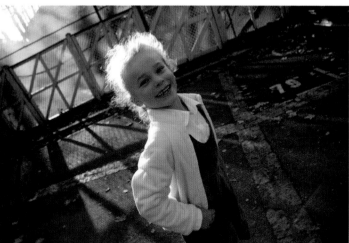

United Arab Emirates > Cardiff 5,795 km

Ukraine > London 2,522 km

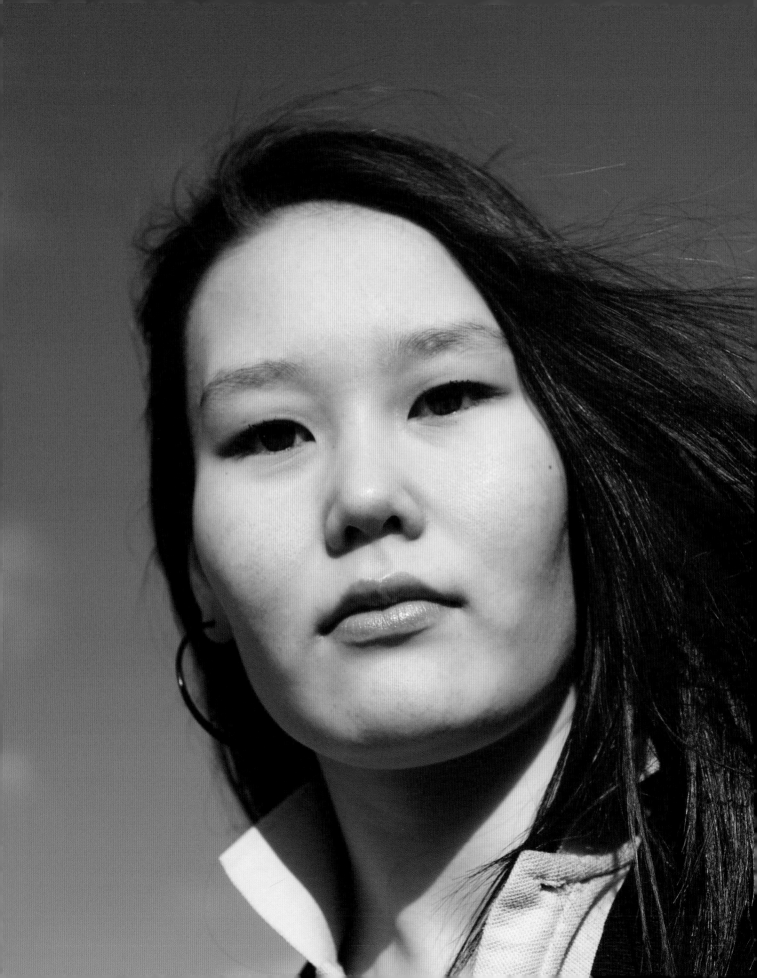

Khulan, 14

I came here because of racism in my country. We're [nomadic] Tuvas, and people used to beat my dad because we're a different origin. When we reported it to the police, they're not going to help us.

My mum and dad came to England one year before me; after they left I used to live with my uncle, aunty and my sister. We lived in a yurt—there's a lot of work if you live in that thing, we got lots to do. We brought wood in to keep the fire up, I used to help with the housework and looking after the animals: sheep, camels, horses....

I didn't go to school that often because there was bullying. If we got free time, my sister just teaches me stuff: how to read and write in Mongolian. Then my sister died—I really don't like talking about how she died. My uncle died as well.

One day a man and woman came. They said, "I'm gonna let you meet your parents." It was really hard leaving my aunt: I don't know when I'm coming back, I don't know if I'm going to see her again.

They take me to the airplane. I'd never been in an airplane— I really had a long journey and then I met my mum and dad in this country. It feels like dreaming, sitting in the airplane and then meeting my parents. I'm used to seeing all those Mongolian people and then now in Europe, all these European people. I never thought of myself living in this country like this, I never dreamed of it.

I really miss everything I was used to in Mongolia: animals, food, yoghurt. I used to ride a horse every day. Sometimes when I'm on the train and I see animals, like horses and everything, I just miss it. I feel like riding a horse.

Mongolia › Leicester 7,036 km

A Child from Everywhere
The Future

Pakistan
Brunei
Uzbekistan
Mexico
Morocco
Costa Rica
Tanzania
Cape Verde
Qatar
Tunisia
Peru
Switzerland
Papua New Guinea
Burundi
Saudi Arabia
India
Libya
France
Belgium
United Kingdom
Cameroon
Eritrea
Syria
Albania
Bahrain
Burkina Faso
Sierra Leone
Lesotho
Ghana
South Africa
Malaysia
Bhutan
Spain
New Zealand

Gabon
Czech Republic
Uruguay
St Vincent and
The Grenadines

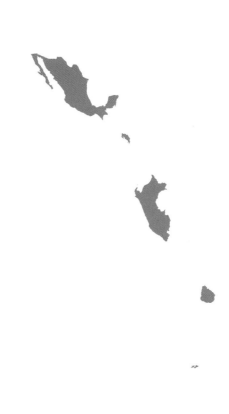

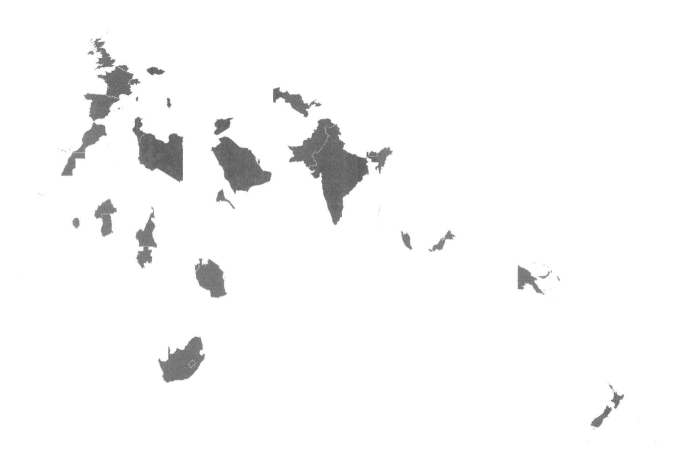

Hassan, 8

My dad's job is to drive a taxi, but it's causing pollution: even in the UK it's getting hot. One day I think the Arctic will be at ten degrees and the UK will be at 30 degrees. I would like to get a big business and get electricity from solar panels. That is if I have enough money.

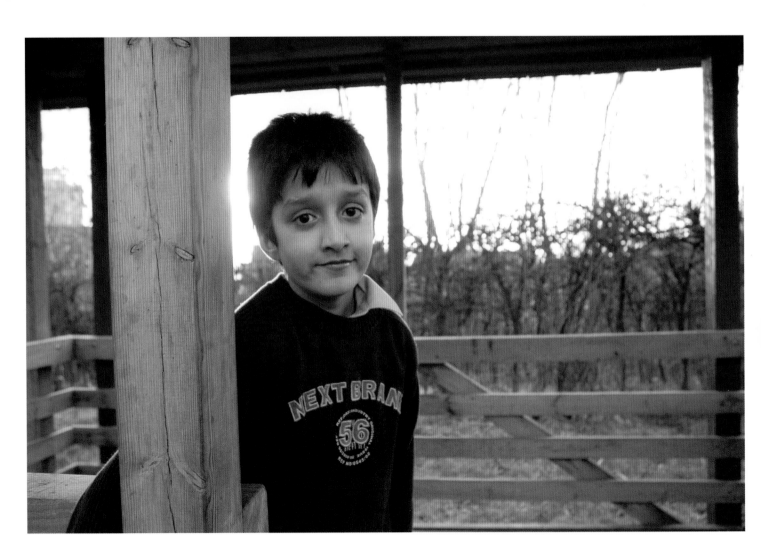

Pakistan > Manchester 6,332 km

Naquiba, 8
I would like to be a doctor.

Shereene, 8
I'd like to be an author, like JK Rowling, or a poetress.
I write poems: I think I know some off by heart.

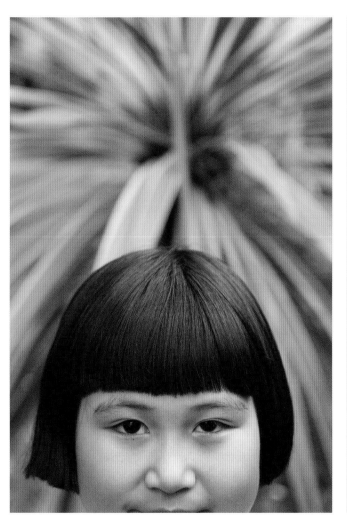

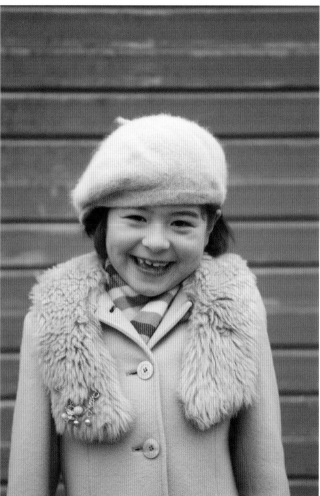

Brunei > London 11,397 km

Uzbekistan > Orpington 5,091 km

Fernando, 11
I used to dance Irish dancing in Mexico, in school. When I'm older I want to be a doctor or a great Irish dancer.

Mounira, 6
I want to be a singer.

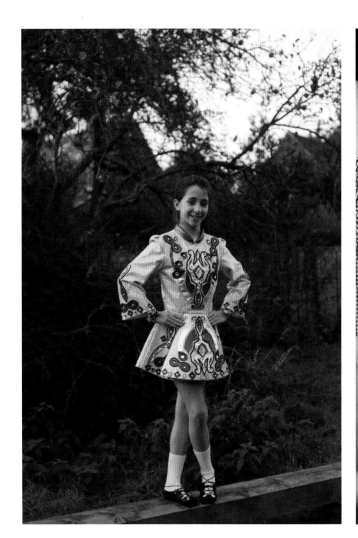

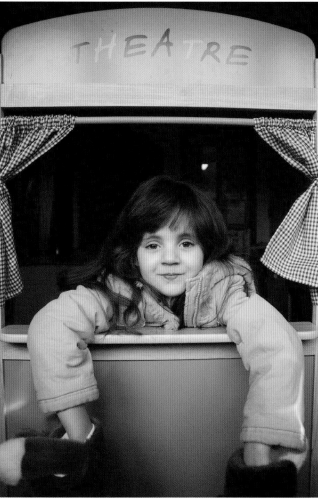

Mexico > Cambridge 8,452 km

Morocco > Manchester 2,446 km

Jose, 6
[I would like to be] a fire fighter.

Sharifa, 15
I want to be a businesswoman but I can't be because I can't speak English properly. My mum can't speak English, there's only my dad who can and he's working all day so he can't teach me.

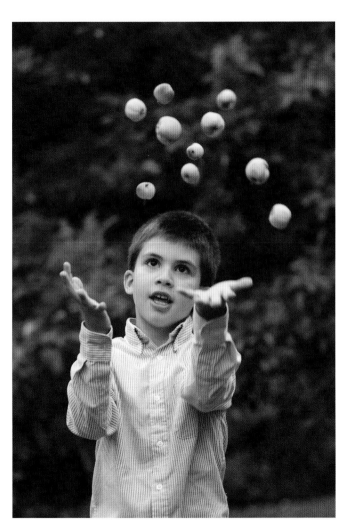

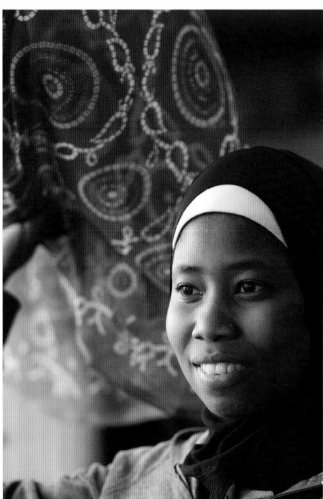

Costa Rica > Oxford 8,451 km

Tanzania > Leicester 7,589 km

Rennie, 10
I'd like to be an interior designer.

Sara, 13
I'd like to be a fashion designer.

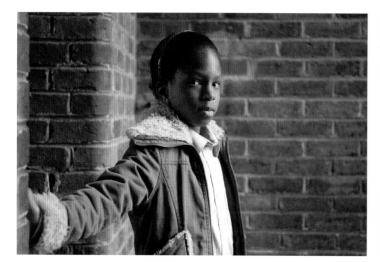

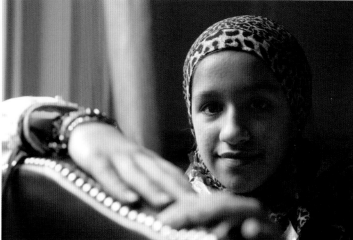

Cape Verde > London 4,563 km

Qatar > London 5,490 km

Sara, 13

Wearing the veil I do get quite a lot of discrimination, but I'm
going to carry on. When I'm older I want to be a lawyer and
work with people from different religions who feel their religion's
getting discriminated. I am who I am, no one's approval is needed.

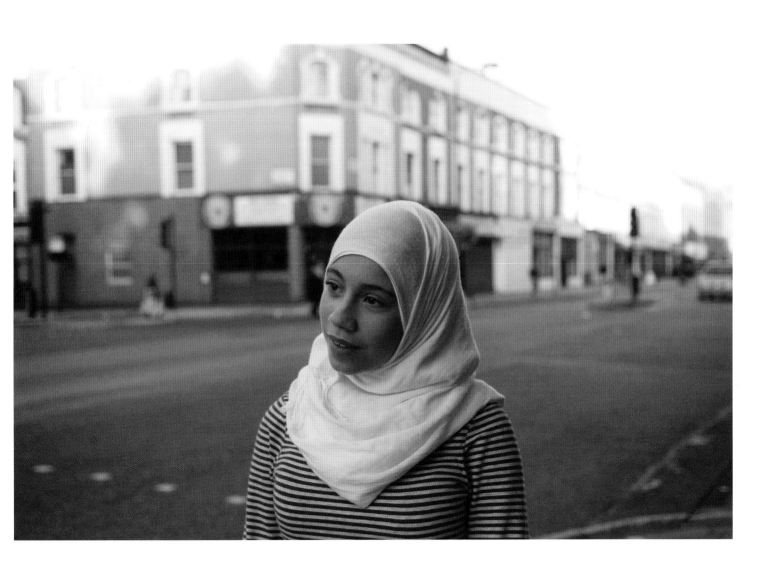

Tunisia > London 2,444 km

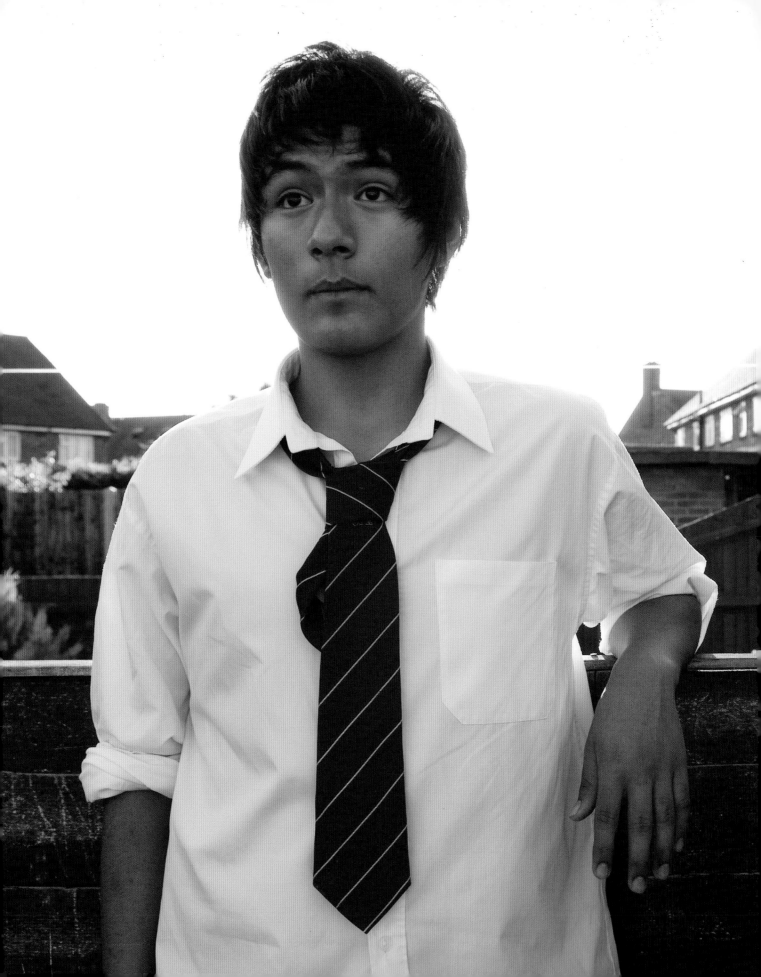

Luis, 15

At the beginning I didn't want to come: I wanted to be with my friends. I had, basically a good life in Peru. If I had the chance I would've stayed there, but my mum insisted me to come to get a better education.

My mother was a doctor. She used to go to poor communities helping people. She took me with her once: I still remember those poor people in the north and in the Amazon, but that was so many years ago.

I think England has changed me so much over the years. When I was in Peru I was confident going out and hanging around in town and stuff, but I'm not as confident about doing those things in England. I don't know why, but I feel like I'm not part of England if you know what I mean.

I don't know if it's naïve to think that if I'm going to stay here and study here, I could go back to my country and make it a better place. My dream would be going to Cambridge. I would like to study medicine and take it back to my country, or get into politics as well cos there's too much corruption in Peru. I would like to end that if I could but I will need to study and work very hard to get there.

I know it's my responsibility to achieve a lot whilst I'm here. I have to do what I have to do.

Peru > Watford 9,756 km

Constantin, 4
I want to be a helicopter pilot in Switzerland, where my toys are.
I can fly to England in my helicopter.

Angelo, 4
I want to be a dragon and live in a dragon place.

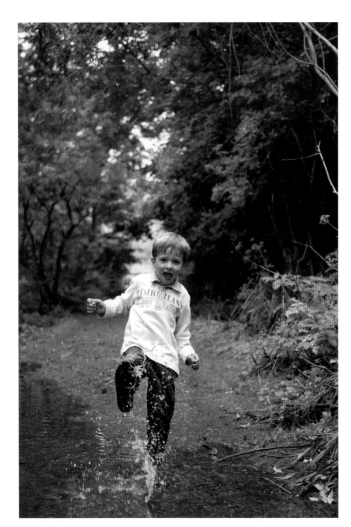

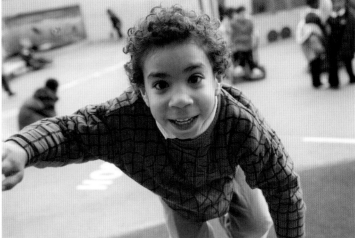

Switzerland > Richmond 1,148 km

Papua New Guinea > Leeds 14,064 km

Doreen and Doris, twins, 5
Doreen: I want to be a police.
Doris: I want to be a princess.

Yomna, 4
I want to be bigger.

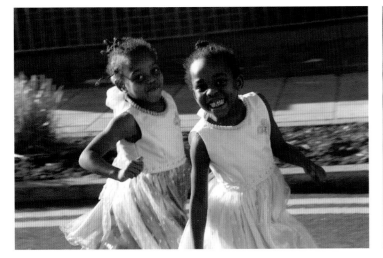

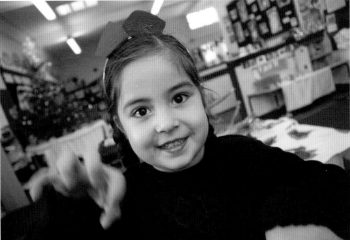

Burundi > London 7,121 km

Saudi Arabia > Birmingham 5,140 km

Anuska, 6
English people speak English, and Indian people speak Indian. In India they have brown skin and in England they have white skin. This is different from my home so I think the correct home is India.

Masarra, 10
My first language is Arabic. All my family's there. I feel I'm Libyan—I wish I was going to Libya.

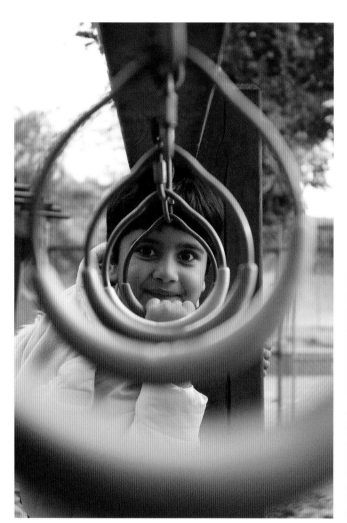

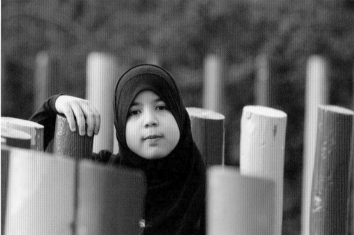

India > Torquay 7,634 km

Libya > Manchester 3,660 km

Aliyah, 6

I wish I live in another country cos I want to see spiders. In Ireland they're small; I want to see different ones, with stripes on them.

France > Portadown 985 km

Elisabeth, 5
I think I'd like to live in Belgium because I can speak in Belgium
and there's so much to say.

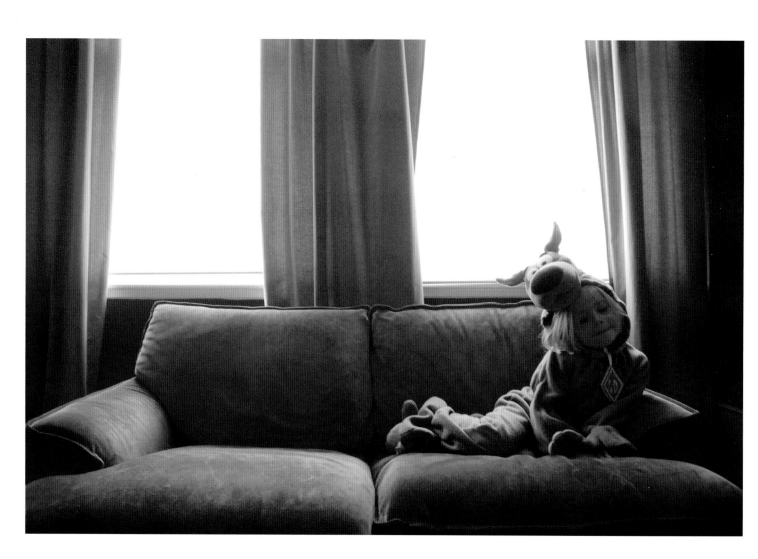

Belgium > London 646 km

Beth, 8

I would like to go to China cos I like the food and there are really cool robots there. I'd really like to see Africa, what it's like to live there. But it's nice to live in Belfast cos it's not as noisy as other places in the world, and it's very easy to get home.

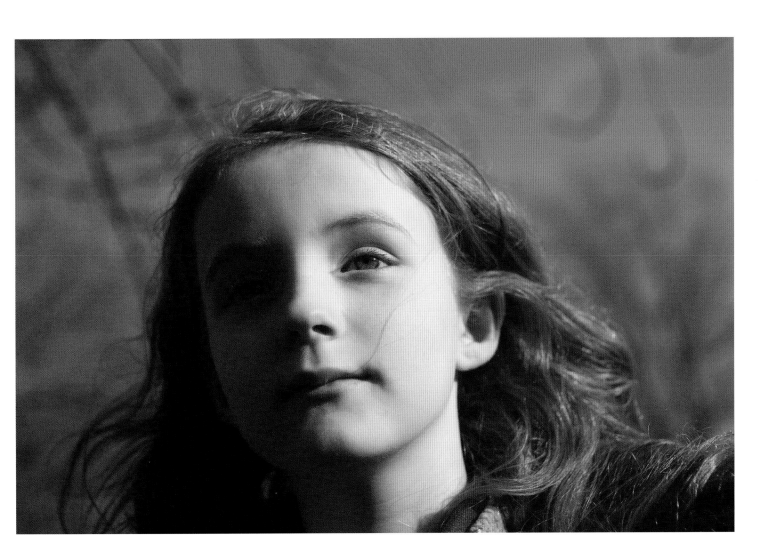

United Kingdom < > Belfast

Zidane, 7
I would like to live in Africa because it's the hottest place. Africa is hot and in Africa we got a swimming pool and we get to do anything we want in Africa.

Ybarak, 13
I want to be an astronaut. I need to be in a great country because my country is not—they haven't got astronauts.

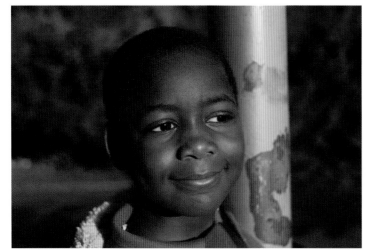

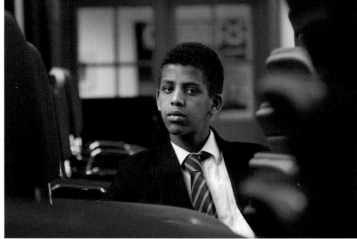

Cameroon > Belfast 5,525 km

Eritrea > Manchester 5,302 km

Moaaz, 11

I feel British but I would like to go back to Syria, go to America,
go to different countries.

Elton, 11

I'd like to live in Spain—most of my mates have been.

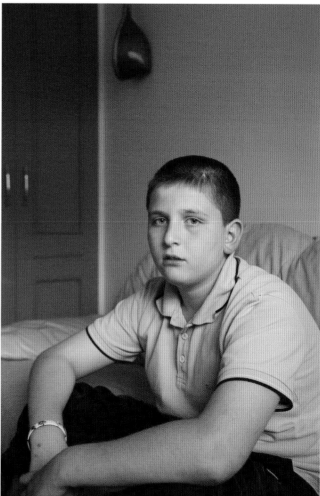

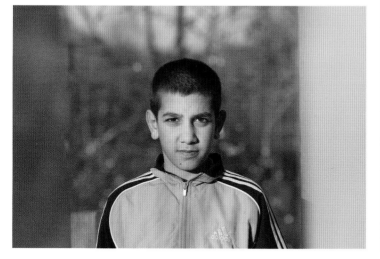

Syria > Manchester 3,859km

Albania > London 2,290 km

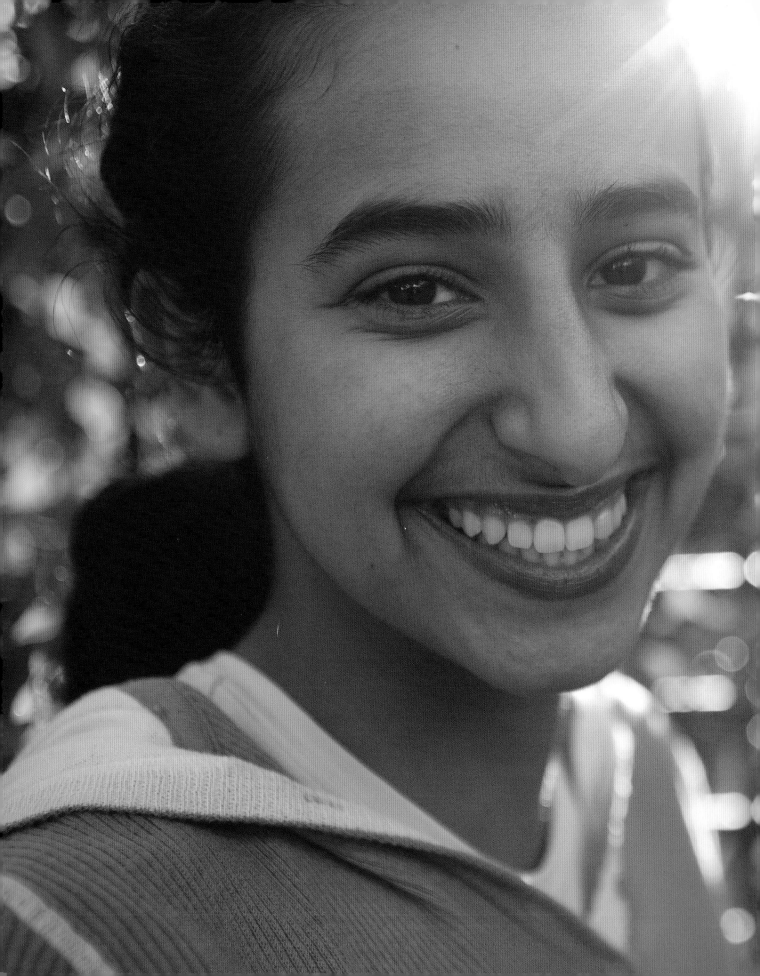

Amna, 15

When I get older, I guess I would be like to be living in.... I was going to say Bahrain but I don't really know what it's turning into. It's more of a competition between Bahrain and Dubai to see who can build faster, and I'm not really sure I want to be part of that. Nowadays Bahrain is becoming very westernised, and any girl that's watched any movie wants to be like an American girl or like a London girl and go shopping. They're very materialistic. And that's kind of why that I feel really lucky and grateful that I haven't lived there my whole life, so I know exactly what I'm missing out on. I know what I could have been and what I'm not.

I've lived in different places: I lived in Bahrain for four years and before that I lived in Washington DC. I've always liked to travel: in my opinion, anyone who hasn't travelled can't really understand what's different about the world and wouldn't have a big imagination as to what is really out there. But at the same time, my family has travelled so much we don't really know a lot, or as much as we should, about our own religion.

I feel at home here. Here, people really understand. They don't judge me, they're just accepting. I've learned that it's definitely within this whole city, I guess because everyone moves in and out, and it's filled with people from all sorts of places. Just walking down the street I see different people, I hear different languages. I even hear Arabic a lot, and it's surprising, and it makes me feel that I'm still connected with my culture at the same time I'm learning about other cultures.

Bahrain > London 5,399 km

Rodrigue, 11

Life here is easy; life in Burkina, it's relaxing when I go for summer holidays, but when I go to stay there forever, I don't know how it will be. My cousins, they're used to the routine, but if I went there I would find it a bit harder.

Shaquille, 11

I went back a few months ago. There wasn't much electricity. People would carry baskets of water on their head and play football on really hard sand and rocks, in slippers. Living there would be quite crazy really. For me who's coming from England, not used to seeing all of this, it would take a while to get used to it.

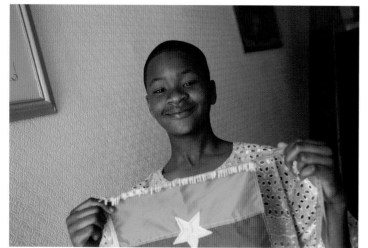

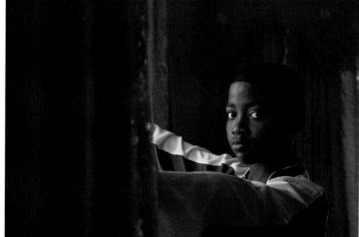

Burkina Faso > London 4,559 km

Sierra Leone > Bexley 5,100 km

Mosetse, 16

A cousin of mine died of HIV in 2004. It's painful because when someone is deteriorating like that, you're helpless. I think it's got worse since I left: I remember learning in school [in Lesotho] that the population is 2 million; now it's less due to HIV and poverty. If I could wish for anything, because it's affecting my country, I'd wish for a cure for HIV/AIDS.

Kwame, 16

I want Ghana to improve. I want Ghana to have the best freedom and the best schools, the best opportunities so we could be the same as here. I want it to be a developed country as well.

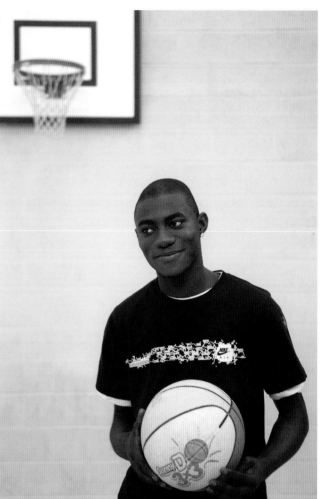

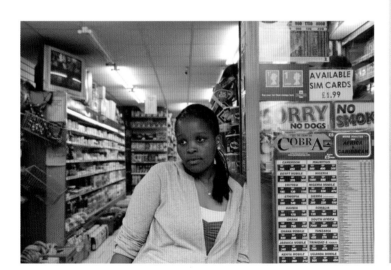

Lesotho > London 9,782 km

Ghana > Leeds 5,114 km

Sibongile, 10
I'm getting a bit more moody since I've been living in the UK, don't know how.

Aisyah, 11
My parents talk about going back but I don't want to go. I think I'll find it hard to make friends there because I don't know how to speak very much Malay.

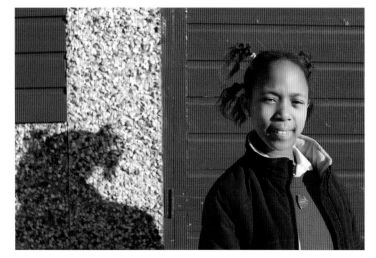

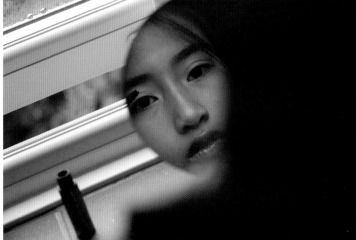

South Africa > Birmingham 9,769 km

Malaysia > Oxford 11,456 km

Trishala, 14

If I was living in Bhutan, I'd probably be really different right now. I probably wouldn't be as confident as I am. There the girls help their mum with the cooking and cleaning. Here I've been doing taekwondo for three years, I've got medals from school for netball and badminton, and a special award for playing football in the boys' team. I've done majorettes, tap dance, ballet, street dancing, ice skating....

Ana, 13

I'd like to keep living here, I don't want to go now. I have my friends here and everything; my life has changed so much. When I go [to Madrid] and see my friends there, our styles are different, the music I listen to is different, everything is different.

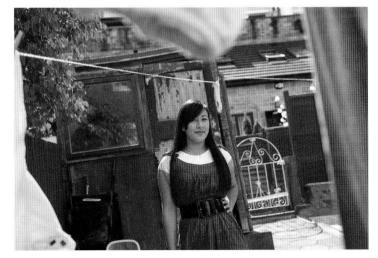

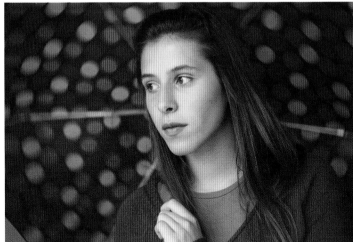

Bhutan > Huddersfield 7,841 km

Spain > London 1,556 km

James, 9
Definitely the UK feels like home. New Zealand's not busy enough for me. In London you've got so many people, you never feel alone or anything cos you'll see people and you'll think, you know, if they're fine then I'm fine.

Ambiah, 6
I don't want to live in Gabon because I don't like bananas.

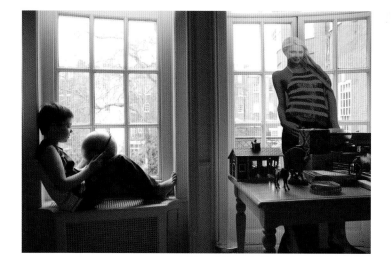

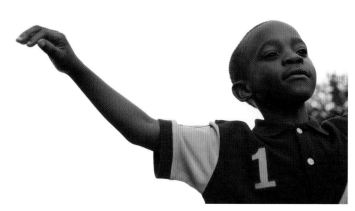

New Zealand > London 18,659 km

Gabon > Ilford 6,281 km

Simona, 11

I wish all my family come here—it's more good here than in my country.

Achilles, 9 months

Achilles' mother, Sofia: If we left, I would miss a lot. Having people from everywhere, listening to different languages... in Uruguay there are only Uruguayans. As long as everything goes fine, we should stay. We like England.

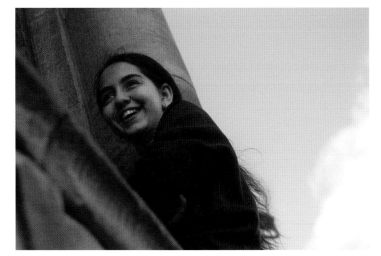

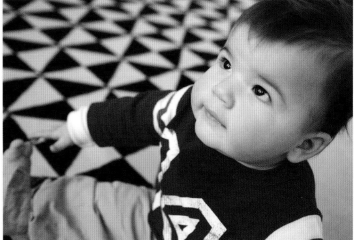

Czech Republic › Leeds 1,381 km

Uruguay › London 10,876 km

Andree-Ann, 10
Ever since my first plane ride I've liked being in the air. I've liked how they look: streamlined, like birds. I dream about being a pilot and flying planes across the world, seeing different people and tasting different foods.

St Vincent and The Grenadines > Enfield 6,281 km

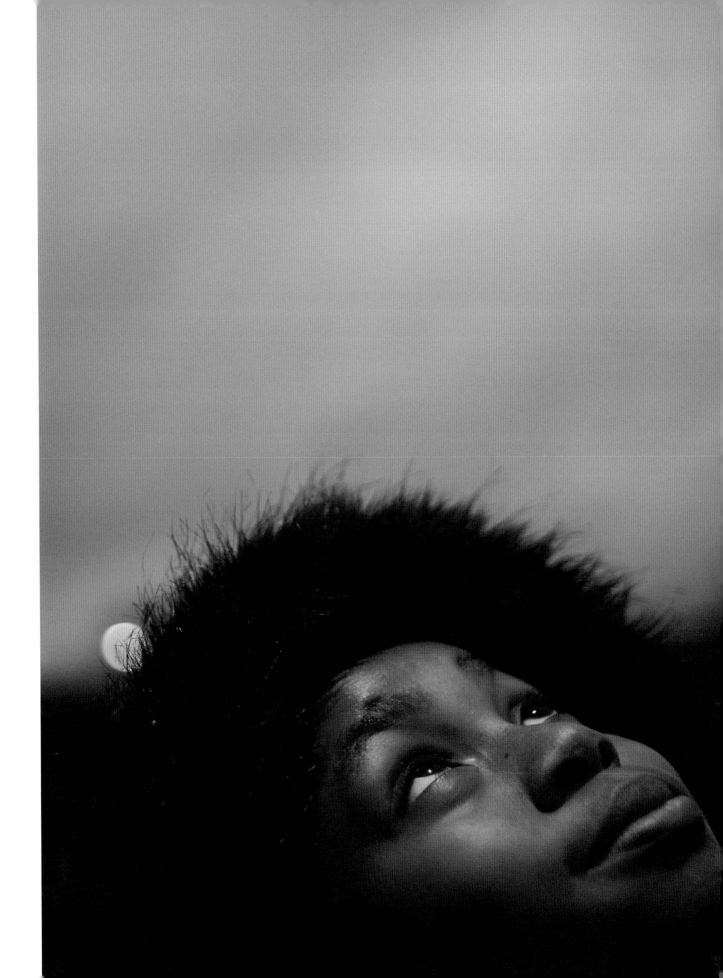

Index

185 Children
185 Countries

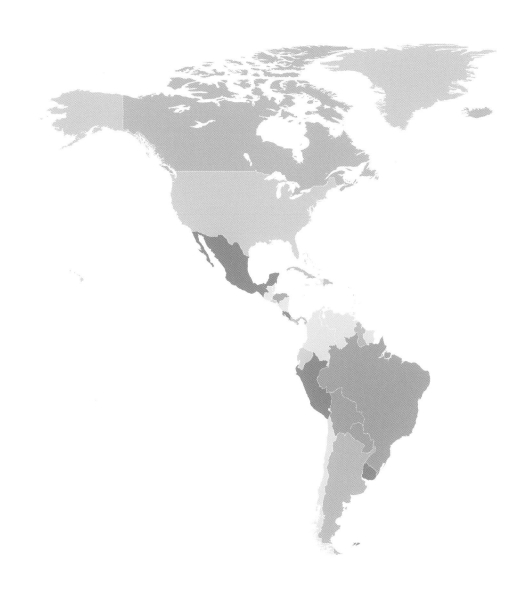

Leaving and Arriving ■ Settling In ■ Being Here ■

Map 157

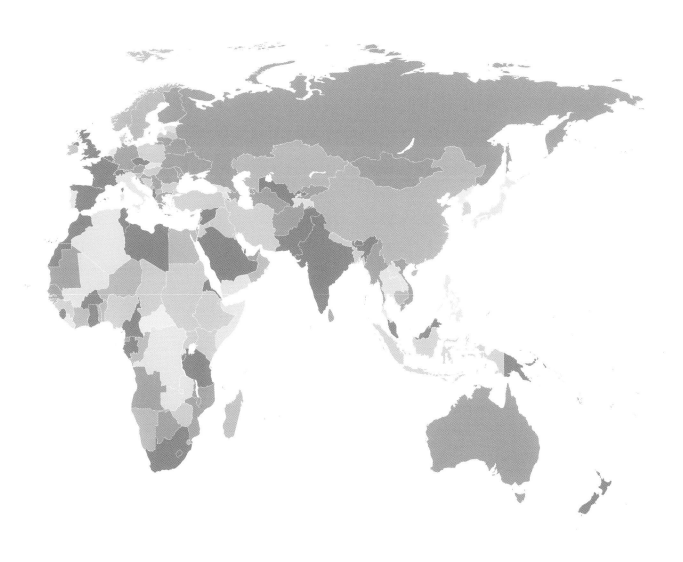

Looking Back ▨ The Future ▨

Acknowledgements

First, my thanks goes to all the children who shared their stories, and to their parents for their trust and for the delicious meals they fed me in their homes.

Next, for listening to me relay these 185 stories over the course of a year, for putting up with long absences, for sound advice, a wonderful eye and brilliant editorial skills, thank you to my husband, the wonderful Tom Cotton.

For their love and constant enthusiasm, and for never, ever holding me back, thank you to my parents, Charles and Sarah Irby.

For first introducing me to another culture and instilling in me a curiosity about other people's lives, thank you to Juning Cifariello.

This project began its life as a magazine feature, became a series of films, then finally took the shape of a book, all thanks to the initiative of a few key people. For first commissioning this project, my gratitude goes to Merope Mills at Guardian Weekend Magazine. For envisaging the project as a series of films, then helping to create those films for Channel 4, thank you to Jamie Campbell and Joel Wilson at Eleven Film. For watching those films and having the imagination to see the work as a book, thank you to Duncan McCorquodale at Black Dog Publishing.

Thank you over many years to my photographic agent, Abby Johnston, for your faith in my work, and recently to my literary agent, Juliet Pickering, for being so supportive of me and this book.

At Black Dog Publishing, thanks to Alex Wright for your patience and thoughtful design. At the Guardian, thank you to Anna Chesters for weeks of transcribing the children's interviews, and to Emily Butselaar for your persistence in tracking down some of these children. Thank you to my friends Elena Heatherwick for helping me and some of the Spanish-speaking children to understand each other, Beth Serota for joining me on part of this treasure trail, and Rosie Apponyi for your guidance as the project became a book . Many thanks to Aminatta Forna for lending your beautiful writing to this book.

To every teacher, councillor, community worker, cultural organisation, university admissions department, embassy, stranger, friend and family member who helped me along the way, thank you.

In memory of 16 year old Kwame from Ghana, who passed away suddenly a few weeks after taking part in this project.

Colophon

© 2010 Black Dog Publishing Limited, London, UK.
All rights reserved.

No part of this publication may be reproduced, stored in a retrieval system, or transmitted, in any form or by any means, electronic, mechanical, photocopying, recording, or otherwise, without prior permission of the publisher. Every effort has been made to trace the copyright holders, but if any have been inadvertently overlooked the necessary arrangements will be made at the first opportunity. All opinions expressed within this publication are those of the authors and not necessarily of the publisher.

Designed by Alex Wright at Black Dog Publishing.

Black Dog Publishing Limited
10a Acton Street
London WC1X 9NG
United Kingdom

Tel: +44 (0)20 7713 5097
Fax: +44 (0)20 7713 8682
info@blackdogonline.com
www.blackdogonline.com

British Library Cataloguing-in-Publication Data.
A CIP record for this book is available from the British Library.

ISBN 978 1 906155 93 3

Black Dog Publishing Limited, London, UK, is an environmentally responsible company. *A Child from Everywhere* is printed on an FSC certified paper.

Is there anything you'd like to ask me?

Did you have fun with your project?
Nada, 8, United Arab Emirates

What country are you from?
Rennie, 10, Cape Verde

Have you ever wanted to be something else?
Amna, 15, Bahrain

Will you come for a sleepover?
Khadija, 8, Senegal

Have you been to Kazakhstan?
I think you'd like it.
Munira, 12, Kazakhstan

Would you like some ice cream?
Nadine, 6, Egypt